IMAGES
of America

GATLINBURG

ON THE COVER: The New Gatlinburg Inn offered Maples Mountain Tours for $7.50, which included a packed lunch. According to Wilma Maples, one mischievous guide told the tourists that hemlock trees grew potatoes. To prove his story, he dug holes around the trees and buried some potatoes. He told Wilma that they believed him! (Courtesy of Wilma Maples.)

IMAGES
of America

GATLINBURG

Kenton Temple and Karen McDonald
Anna Porter Public Library

ARCADIA
PUBLISHING

Published by Arcadia Publishing
Charleston, South Carolina

Printed in the United States of America

Library of Congress Control Number: 2011923769

For all general information, please contact Arcadia Publishing:
Telephone 843-853-2070
Fax 843-853-0044
E-mail sales@arcadiapublishing.com
For customer service and orders:
Toll-Free 1-888-313-2665

Visit us on the Internet at www.arcadiapublishing.com

This book is dedicated to Shannon Barrett, Ethel Hamlin,
and Carol Bennett—the staff at Anna Porter Public Library.
They kept up with daily library business so we could put this
book together. It took all of us to make this happen.

CONTENTS

ACKNOWLEDGMENTS

The images in this volume appear courtesy of the Arrowmont School of Arts and Crafts (Arrowmont); the Great Smoky Mountains National Park (GSMNP); the Southern Highlands Craft Guild (SHCG); Tennessee State Library and Archives (TSLA); Thompson Photograph Collection; McClung Historical Collection (Thompson/McClung); Blouin Collection, Anna Porter Public Library (Blouin/APPL); Vic Weals Collection, Anna Porter Public Library (Weals/APPL); and the individuals noted in each caption.

While this project was based on the materials listed in the bibliography, the two especially useful works were that of Dr. Carroll Van West and Kristen Luetkemeier of the Middle Tennessee State University Center for Historic Preservation and the Sevier County Heritage Book Committee. A complete bibliography can be found at www.annaporterpl.org/GatlinburgBibliography.

Many Gatlinburg residents shared their pictures and their stories, especially Frances Fox Shambaugh and Charlotte Connor, as well as Nancy Hays, Bud Lawson, Jim Gerding, Janis Frederick, Sammy Soehn, Wilma Maples, and JoAn Trentham. Ron Blouin shared the Gatlinburg postcard collection that his wife, Nancy, gathered on the couple's many visits to Gatlinburg. Candace Grimm helped track down photographs.

Finally we are indebted to the many people that have maintained Anna Porter Public Library throughout a history that is closely entwined with the history of Gatlinburg.

Anna Porter Public Library is a nonprofit corporation, a 501(c)3, with a contract to provide library services to the city of Gatlinburg. The library has been part of Gatlinburg's history since 1932 when Anna Wheaton Porter started a library in her home on Burg Hill. She wrote to her friends in Iowa asking them "to send her books for the children of Gatlinburg have nothing to read." Porter's neighbors included Jeannette Greve and Laura Thornborough, who both wrote books about Gatlinburg, and Georgia M. Duffield, a weaver in charge of the Pi Beta Phi Settlement School's showroom at the Mountain View Hotel. The library moved to a space in Allie Ownby's Smoky Mountain Craft Shop, to a space above the bus station, and to one of Charles Ogle's white frame houses situated where Mountain Mall is today. When the library was incorporated in 1940, the charter was signed by Eunice Weaver with the Pi Beta Phi Settlement School and Pearl Whaley, Ethel Voorheis, and Judith Holt, wives of influential civic leaders. The City of Gatlinburg, which did not incorporate until 1945, provided dedicated library space in the new Mills Auditorium and convention center complex in the 1950s. The city built a stone building for the Anna Porter Public Library on Cherokee Orchard Road in 1972. In 2009, the city and the Gatlinburg community constructed a larger library building adjacent to the Gatlinburg Community Center and near Gatlinburg Pittman High School, with a view of Mount LeConte in the Great Smoky Mountains National Park.

INTRODUCTION

Gatlinburg is not an ordinary small town. Its first 100 years were not so different from other Appalachian mountain communities. Then, early in the 20th century, three components came together to change a thriving but isolated hamlet into a major tourist destination. The ladies of the Pi Beta Phi Fraternity for Women, who first visited the area in 1910, were the first component to effect the changes that would make Gatlinburg unique. The second component consisted of the visitors associated with the establishment of the Great Smoky Mountains National Park who began coming to Gatlinburg in the 1920s. The third component consisted of all the people of Gatlinburg who took the ideas and the opportunities to which they were exposed and used their own unique qualities and abilities to create a community and an economy that supports thousands and entertains millions.

The first Europeans to settle the area that would be Gatlinburg arrived in family groups in the first half of the 19th century. Martha Jane Huskey Ogle came in 1795 with six sons and two daughters and her brother Peter Huskey. William Ogle, her husband, had been here earlier but died before the family could make the trip across the mountains. Tennessee became a state in 1796, but the pioneers would have been more concerned with building cabins and feeding themselves. Martha Jane's oldest son, Isaac, bought 50 acres of land and built a log house. When this one burned, he built another, and someone carved the year 1807 into its wood.

Settlers continued to arrive, and by 1817, Martha Ogle and the other women asked that a church be established in the community along the Little Pigeon River called White Oak Flats. Although most of the early settlers were Presbyterian, the closest established religious denomination was a Baptist congregation in the Sevierville area, so the first church was a Baptist missionary project. In 1835, the White Oak Flats Baptist Church was incorporated as its own congregation. Church communities continued to play an important role in Gatlinburg society throughout its history.

The year after a church was established, the White Oak Flats Post Office was opened with William Trentham as postmaster. Schools were opened in 1839, and 10 years later, in 1850, they were funded with county taxes. Noah Ogle opened the first store in the same year. Although isolated, White Oak Flats had established itself as a place with a solid enough future to continue to entice newcomers.

Among the newcomers was Radford Gatlin, who came to White Oak Flats in 1854 and established the second store. By 1856, the post office was operating out of Gatlin's store building. By 1860, the post office was named for Gatlin, the town's name was Gatlinburg, and Radford Gatlin, with his Confederate tendencies, was run out of Republican Gatlinburg.

After the Civil War, during which Gatlinburg was occupied by Confederate forces that were driven from town by Union forces in the Battle of Burg Hill, the town continued to grow. In 1867, a state-supported school was opened in a log house owned by C.C. Reagan and Caleb Trentham built the first sawmill on the Little Pigeon River. A second Baptist Church building was constructed across Baskins Creek from the original structure in 1885.

By 1910, Lou Harshaw, in *Gatlinburg Places of Discovery,* wrote that Gatlinburg consisted of a dozen houses, three stores, a church, a school, a blacksmith shop, and a furniture shop. Clearly the mountain people valued commerce, religion, education, and handcrafts, values that would stand them in good stead, as the outside world was about to enter and change Gatlinburg forever.

One

FIRST SETTLERS
AND EARLY YEARS

A trip to Gatlinburg from Sevierville around 1900 involved navigating a narrow road that only ran along the west side of the Little Pigeon River before it bridged the rocky stream to continue along the east bank. The view from the road broadened as it entered the valley or "flat" that was Gatlinburg. The town consisted of white frame buildings, some log structures, and open fields. The slopes were treeless since the lumbering industry was in full swing, and the land was needed for orchards and corn and other crops.

The people were self-sufficient, depending on their own skills and that of their neighbors to thrive in a barter economy. Shoes could be made by hand as well as the turbines for the mills that were prevalent along the many creek sides. They built with the boards and shingles they made themselves and had woven their own cloth before manufactured cloth became readily available. These skills would be a basis for the development of arts and crafts businesses in the years to come.

In the last years of the 19th century, the logging industry discovered the timber in the Smoky Mountains, and in 1903, the Little River Lumber Company came to Townsend, Tennessee. Ed Trout wrote in *Cinderella City*, "Although Gatlinburg proper was on the fringes, the hubbub of logging roared all around and touched the lives of most . . . Hardly a name in town was not echoed in the forest camps." Andrew Jackson Huff moved his sawmills to the area and built a two-story white frame house.

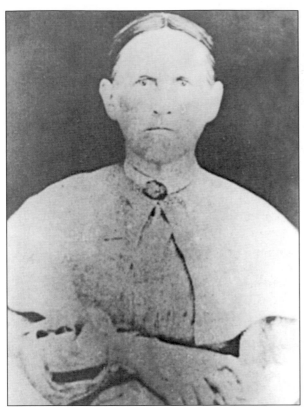

Martha Jane Huskey Ogle has traditionally been pictured as the forbidding-looking woman in this photograph. Since her date of death is recorded as 1825, and since photography probably was not available in what is now Gatlinburg, it is more likely that the woman portrayed here is one of her daughters, Rebecca or Mary Ann. (Courtesy of APPL.)

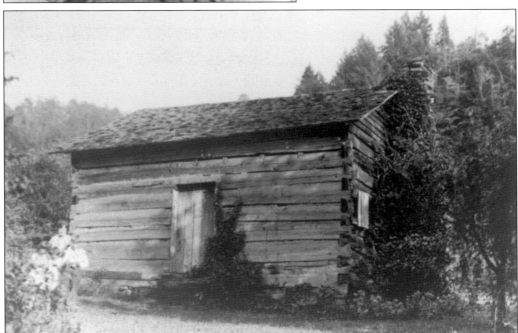

This cabin was the early home of Martha Jane Huskey Ogle. A carved date indicates that it was built in 1807. She arrived from North Carolina as a widow with her brother, six sons, and two daughters—quite a crowd for this small building. (Courtesy of JoAn Trentham.)

Pictured in this 1927 photograph are Andrew Ogle and his wife, Martha Trentham. He was the great-grandson of William and Martha Huskey Ogle and the last Ogle to live in the 1807 cabin. (Courtesy of GSMNP.)

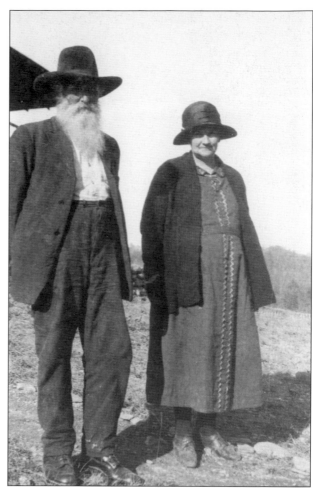

This four-room home was built about 1910 by Andrew Ogle just below the site of the 1807 log cabin. (Courtesy of Arrowmont.)

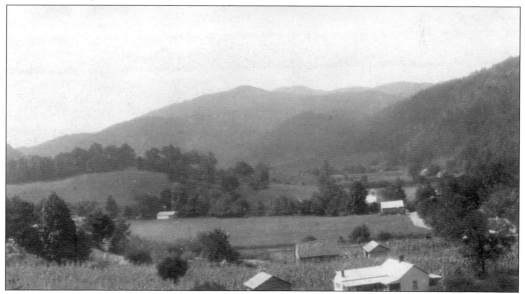

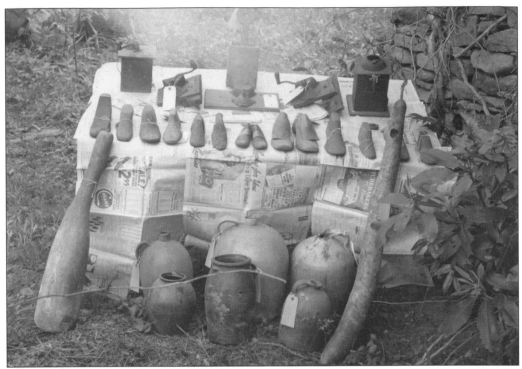

This collection of shoe lasts and old tools indicates the self-reliance of the mountain people who depended on themselves and their neighbors for the necessities of daily life.

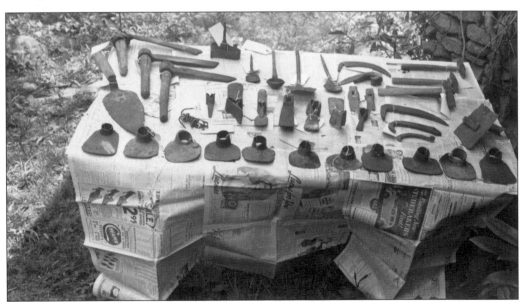

Tools like these and the know how to use them were a necessity in a community comprised of, according to the 1860 census, 84 farmer/farm laborers, four day laborers, spinster/weaver/seamstress types, two Baptist ministers, and one idiot. (Courtesy of GSMNP.)

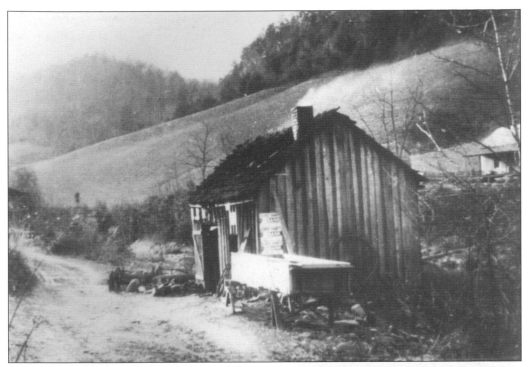

C.C. Reagan's blacksmith shop was one of the seven commercial buildings listed as being in Gatlinburg in 1910. It was located on River Road at the south end of town. (Courtesy of GSMNP.)

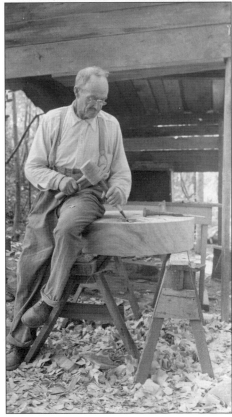

In this 1936 photograph, Uncle Ike Bradley is fashioning a turbine for a tub mill. Ideally suited to mountainous terrain, tub mills were the size of an outhouse, fit along narrow stream banks, and could produce a bushel of cornmeal a day. (Courtesy of GSMNP.)

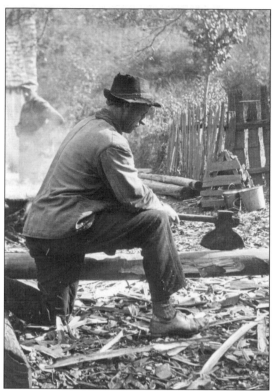

L.W. McCarter is shown in this 1930s photograph hewing logs in the manner of all early and skilled home builders. Cabin builders in the Smokies typically squared their logs, presumably to make them fit together more easily. (Courtesy of GSMNP.)

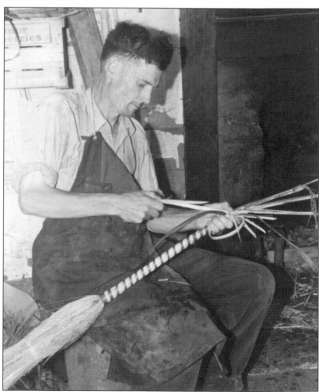

Elmer Kear utilized a useful skill of the early settlers as he crafted brooms in his home in the 1930s to be sold to tourists. (Courtesy of Arrowmont.)

Wiley Gibson is shown cleaning a gun. Gunsmithing and shooting were necessary abilities for the mountain people. (Courtesy of GSMNP.)

Jackson Ownby, shown here in a 1937 photograph, is "splitting boards," known as shingles in other areas, from red or white oak. Ownby was to make the "boards" for the Mountain View Hotel and other Gatlinburg buildings. (Courtesy of GSMNP.)

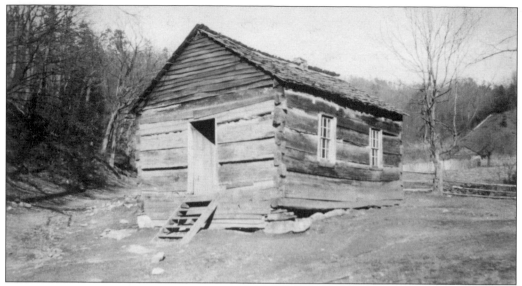

This log building functioned as both a school and a church in the "Baskins" Creek area, named for the "bearskins" that were abandoned by hunters farther up the creek. Although the early settlers were strongly Scots Presbyterian, the Sevierville Baptists sent missionaries, and the little log church became known as the Little Valley Baptist Church. Churches have been important continuously in Gatlinburg since Martha Huskey Ogle and other women asked that a church be established in White Oak Flats in 1817. (Courtesy of Arrowmont.)

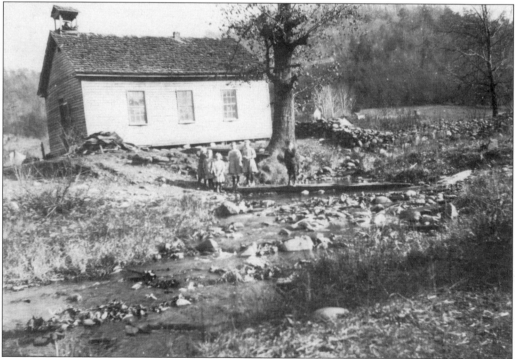

A second church building was constructed and used for services and schooling until 1835. Even though schools were available and illiteracy was not prevalent, education probably did not progress beyond fifth-grade level. (Courtesy of Bud Lawson.)

This third Baptist church was constructed in 1885 across Baskins Creek from the second building. By this time, the local church organization had separated from the Sevierville Church and incorporated in 1835 as the White Oak Flats Baptist Church. (Courtesy of Arrowmont.)

This cabin is an example of the "saddlebag" configuration that featured two units sharing a common center chimney. Families were large and multigenerational, and the cabins' interiors were utilitarian but not necessarily drab, since magazine pages used for insulation decorated the walls and bright quilts covered the beds. (Courtesy of Arrowmont.)

Caleb Trentham, who operated the first mill in the area on the Little Pigeon River at Sugarlands in 1868, built the lumber mill and dam in this 1932 photograph. (Courtesy of JoAn Trentham.)

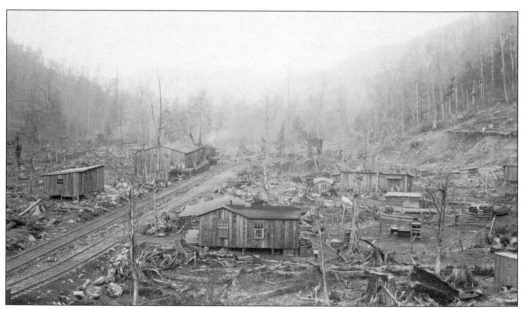

This early logging camp was one of many established in the Smokies by lumberman Andrew Jackson "Andy" Huff, who came in 1900 from Greene County to Gatlinburg, where he met his wife, Martha Whaley. (Courtesy of Arrowmont.)

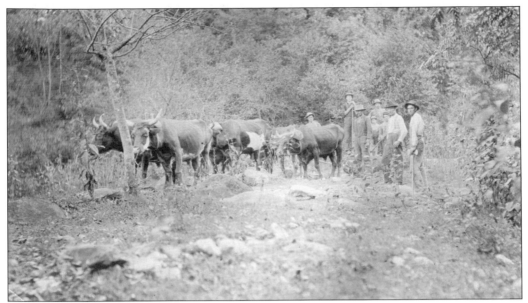

Using oxen to haul logs was one of two ways to get wood to a sawmill. The other way was to get the logs to a creek and let rain do the work. (Courtesy of Bud Lawson.)

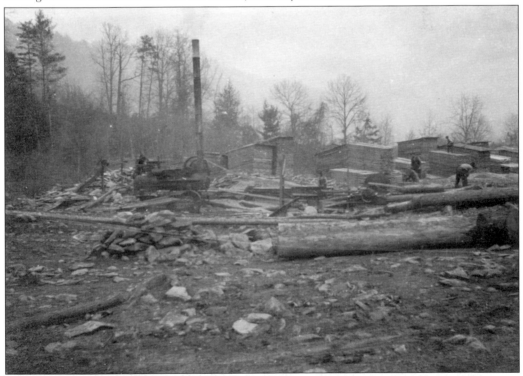

As the demand for timber grew, sawmills, such as this one belonging to Andy Huff, spread throughout what would become the Great Smoky Mountains National Park. Eventually substantial tracts of timberland would have to be acquired from companies like Champion Fibre Company, which owned 92,815 acres, including Mount LeConte, and the Little River Lumber Company in the Elkmont area. (Courtesy of Bud Lawson.)

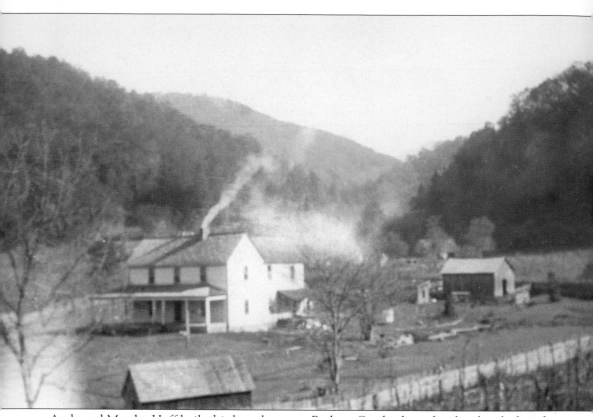

Andy and Martha Huff built this large home up Baskins Creek where they lived with their five children. (Courtesy of Bud Lawson.)

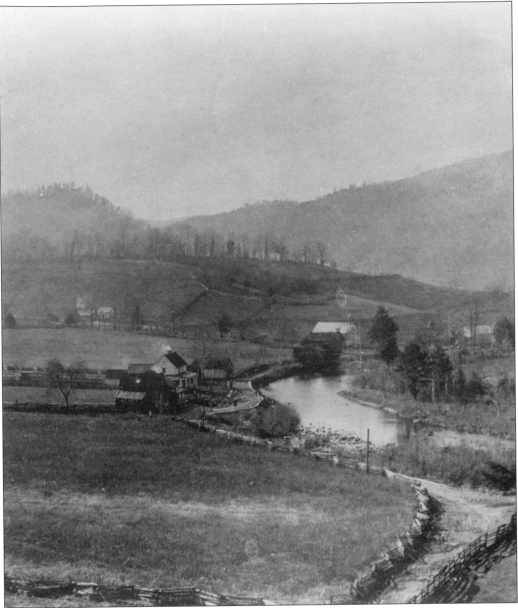

Gatlinburg in 1913, when this picture was taken, was mostly farmland. Buildings in 1910 were listed as a dozen houses, three stores, a church, a school, a blacksmith shop, and a furniture shop. (Courtesy of JoAn Trentham.)

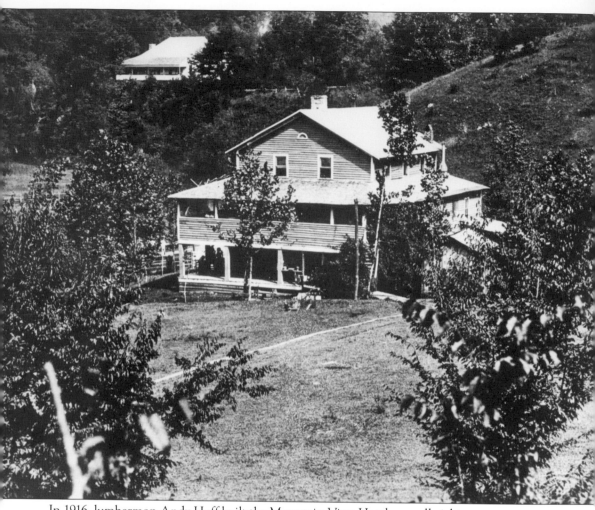

In 1916, lumberman Andy Huff built the Mountain View Hotel, a small eight-room structure, to accommodate the lumber buyers who came to purchase his timber. (Courtesy of Arrowmont.)

Two

The Coming
of the Pi Phis

In 1910, the ladies of the Pi Beta Phi Fraternity for Women chose Gatlinburg for a project and changed the town forever. They opened a school and brought much more than "book learning" with them. The Pi Phis, as these ladies have become known, introduced commerce on a larger scale and brought some of the sophistication of the wider world that existed beyond the mountain coves and hollows. Later, they would be instrumental in spreading the word of Gatlinburg's attractions throughout the country.

The road to Gatlinburg from Sevierville was called "nineteen miles of the worst road in the state of Tennessee" and the paving ended at Pigeon Forge. The road ran through the "Burg," as the local people referred to Gatlinburg, and on to the Sugarlands community. That road would be known over the years as main street, or Highway 441, and later the Parkway.

The Pi Beta Phi Settlement School was opened in 1912. In 1914, the Gatlinburg community, led by lumberman A.J. "Andy" Huff, raised the money and bought the land on which a permanent school would be built. In 1915, the Pi Beta Phi Settlement School offered, in addition to basic educational skills, classes in agriculture, horticulture, and raising poultry. An Arts and Crafts Department that taught weaving was added. Soon a university-trained nurse arrived to open a clinic in Gatlinburg. This clinic would function as the only hospital in the area for many years.

The revival of local crafts was "powered by the old folks and steered by Pi Phi," as Ed Trout put it. Weaving cloth had been a necessity and basket making for home use still continued. The women may have put their looms away but they could certainly get them out again. The Pi Phis would provide a market and education to improve on products that had long been valued necessities for daily life.

Others were discovering Gatlinburg at this time. Outdoor adventurers came to wander in the mountains. Town people came to buy handmade baskets and weaving and then bought furniture and woodworks. Lumber buyers came to purchase the raw wood. A movement to establish a national park began. The local people welcomed the visitors, their cash incomes improved, and Gatlinburg's economy grew.

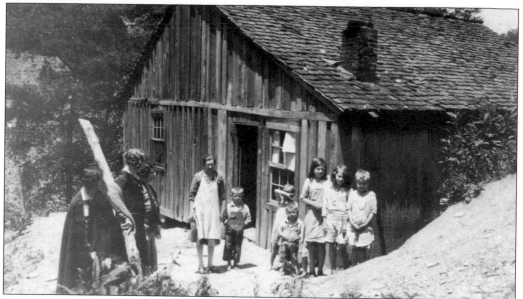

In 1910, the Pi Beta Phi Fraternity for Women chose Gatlinburg in which to open a school that would provide education and economic improvement in a nonsectarian manner. In this photograph, college-educated Pi Phi women are visiting the house on Baskins Creek of weaver Anna Reagan. (Courtesy of Arrowmont.)

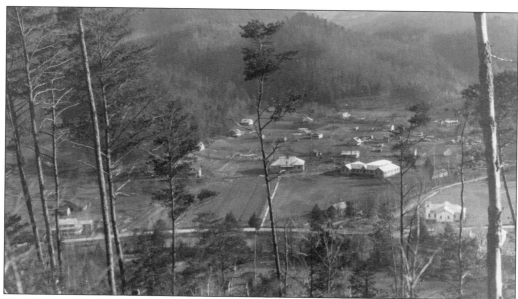

The Pi Beta Phi Settlement School opened in 1912 in the old church and schoolhouse at the corner of Baskins Creek and the Little Pigeon River with one teacher and 13 pupils on land bought from Ephraim E. Ogle in 1914 and paid for by local people, led by Andy Huff. This is a later picture of the school taken from Burg Hill. (Courtesy of Arrowmont.)

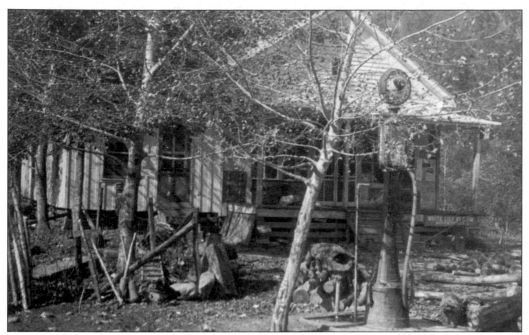

Shown here is a 1926 picture of E.E. Ogle's Store with a gasoline pump. Ogle's son Charlie fired off firecrackers in front of the store in 1913 to celebrate the acquisition of the land that would allow the Pi Phis to start a school in Gatlinburg. (Courtesy of GSMNP.)

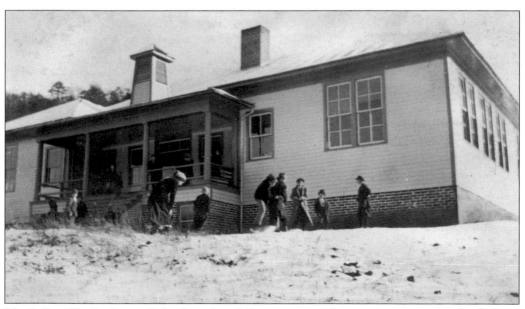

The Pi Beta Phi Settlement School was founded to provide employment by creating local industries. Pictured here is the first five-room schoolhouse built in 1914 for $3,735.30. Students learned basket making, weaving, and woodcarving. (Courtesy of Arrowmont.)

Phyllis Higginbotham was a university-trained nurse brought to Pi Phi in 1920 to open a clinic. She also answered calls on horseback. With her in the photograph is Dr. Walker (first name unknown). Higginbotham was nurse at Pi Phi until 1926 and a much-loved person. (Courtesy of Bud Lawson.)

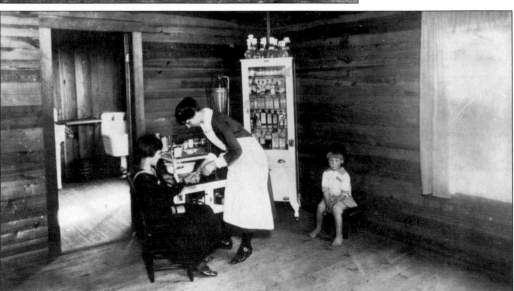

In this photograph from the 1920s, Nurse Higginbotham is treating a patient at the Jennie Nicol Health Center. This clinic functioned as the first hospital in Gatlinburg and eventually moved in 1948 into the building on the Parkway that is still used today by the Arrowmont School for Arts and Crafts. (Courtesy of Arrowmont.)

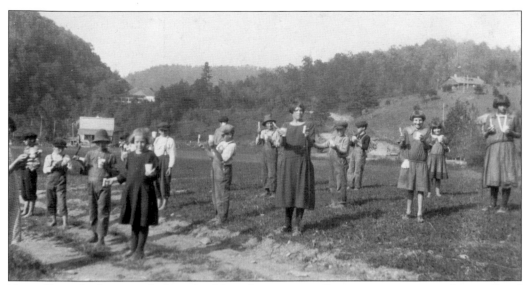

Nurse Higginbotham taught basic health techniques as well as treating ax cuts and copperhead bites. Shown here is a toothbrush drill. (Courtesy of Arrowmont.)

The frame house in this picture was part of the Andrew Ogle farm. When the Pi Phis bought the farm in 1921, the frame house became the clinic. (Courtesy of Bud Lawson.)

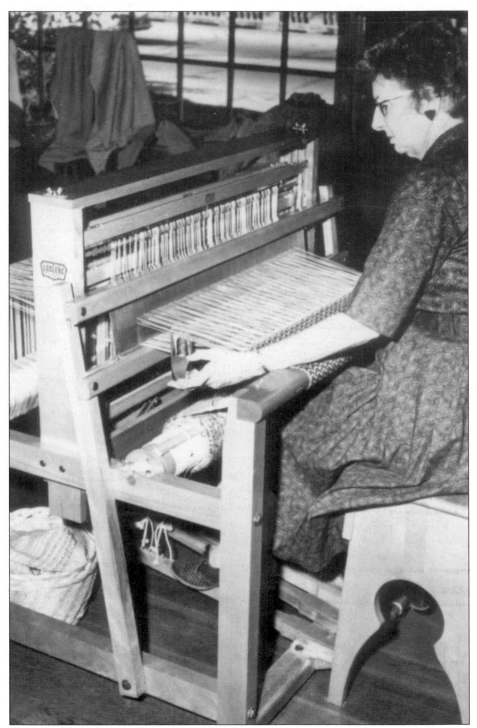

Winogene Redding was hired in 1923 to revive weaving. Women were then encouraged to bring out their looms from where they were stored when store-bought cloth had become available. In a photograph from a later date, Redding is shown weaving on a four-harness loom from the 1940s. (Courtesy of Arrowmont.)

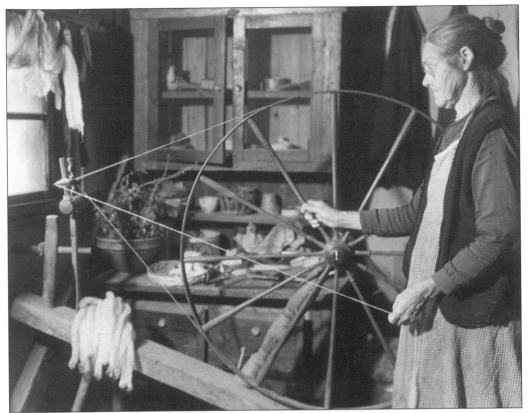

"Aunt Lizzie" Reagan, seen here spinning in her home, was hired as the Pi Beta Phi Settlement School housekeeper and so functioned as a link between the townspeople and the school. (Courtesy of Arrowmont.)

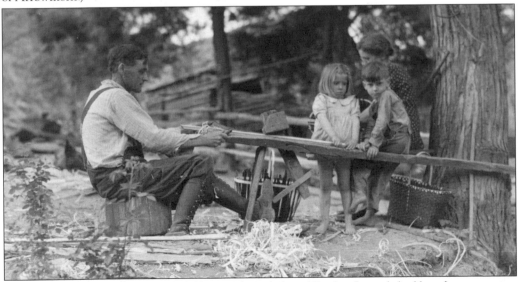

An unidentified carpenter is pictured here making a chair. The local people had long been creating their own furniture and handwoven cloth, so furniture making and weaving were incorporated into the Arrowcraft trademark. (Courtesy of Arrowmont.)

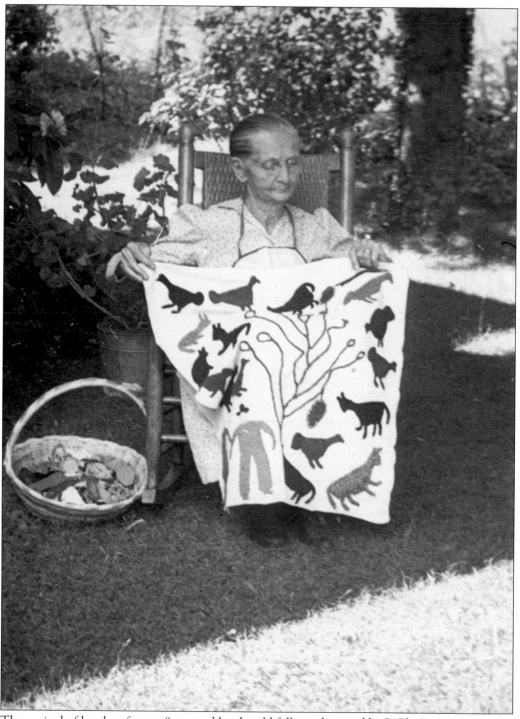

The revival of local crafts was "powered by the old folks and steered by Pi Phi," according to Ed Trout. Here, Granny McDonald is showing an appliqué quilt. (Courtesy of Arrowmont.)

Three

CRAFTING TO SELL
CATCHES ON

In 1915, the Pi Beta Phi Settlement School, simply called Pi Phi by the local people, began to sell locally handmade items through the alumnae department of the Pi Beta Phi Fraternity for Women (Pi Phis). Local crafts men and women would walk or ride long distances to bring their wares to the Pi Beta Phi Settlement School. In 1926, the first Arrowcraft Shop, then called Arrow Craft, was begun. According to Dr. Carroll Van West, the girls were encouraged at the school to make the sort of baskets, patchwork quilts, and handwoven coverlets and blankets that they had grown up using. By 1935, weaving was a major industry in Gatlinburg.

Farmers who had made chairs to pull up to the family table now made them in quantities to sell. A University of Tennessee graduate was brought in by the Pi Phis to teach woodworking, and Gatlinburg developed a furniture making tradition that became another major industry. Ten thousand dollars worth of products was shipped out in the fall of 1926.

The Pi Phis added buildings and renovated others. The Arrowcraft Shop was moved into the old school building in order to display handmade goods for the new tourists. A new stone high school was built to meet the demand for education. A Weavers Guild was organized and meetings included a variety of subjects and speakers. This group eventually became the Gatlinburg Garden Club.

Meanwhile, talk of establishing a national park picked up, and surveyors, photographers, and highway engineers as well as lumbermen, outdoor-oriented tourists, and handmade craft enthusiasts visited Gatlinburg. The State of Tennessee built a two-lane road to Newfound Gap to prepare for the park's coming and called it Highway 441. The townspeople looked around and knew exactly what they could do next—they could expand their economy and provide hotels, restaurants, and shops for the new "tourists."

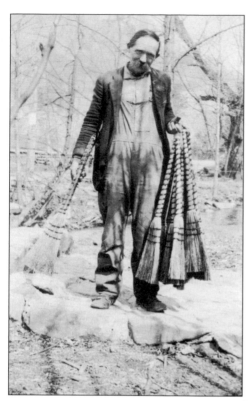

The local people were quick to react when they found they could make money by doing what they had been doing for years out of necessity. Richard Ogle, pictured here, was one of the first to offer sale items in the first Arrow Craft Shop, soon condensed to Arrowcraft. His father is said to have learned broom tying from an Indian. (Courtesy of Arrowmont.)

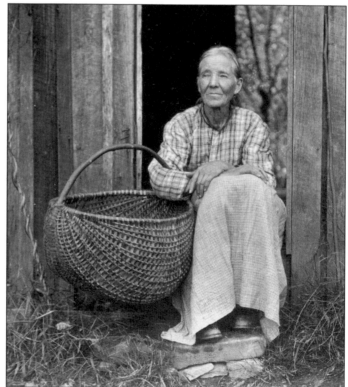

Lydia Whaley, shown here with one of the baskets she made, assisted the school in selling locally made products and also benefited from the prevalence of this well-known photograph. (Courtesy of SHCG.)

Aunt Sophie Campbell, pictured here with her grandson, made pipes out of clay and cane and sold them for 15¢ each. (Courtesy of GSMNP.)

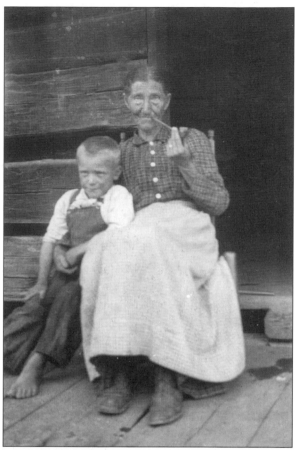

Charlie and Harve Reagan made three-legged stools, called "crickets," to sell at Pi Phi. (Courtesy of Arrowmont.)

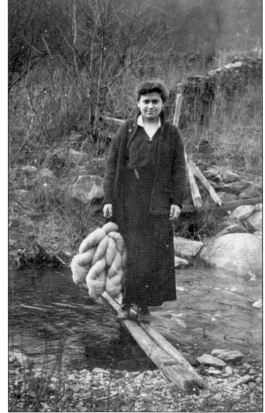

"Aunt Sallie" and Sam Compton brought baskets on horseback for sale at Pi Phi. The family was long known for fine woodwork, and grandson Shirl Compton opened Wood Whittlers in the 1940s. (Courtesy of Arrowmont.)

Helen Weinberg is shown here carrying yarn home on foot from Pi Phi. The weavers would travel to the Pi Beta Phi Settlement School for the yarn, return home to do the weaving, and then take their completed products back to the school to be distributed to sell. (Courtesy of Arrowmont.)

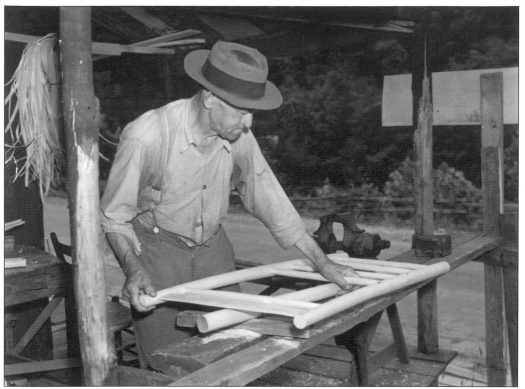

Shown here is Mack McCarter assembling a chair in his shop. Green wood would be used for the crosspieces and inserted into drilled holes in the uprights. As the wood cured, the joints would tighten up. (Courtesy of GSMNP.)

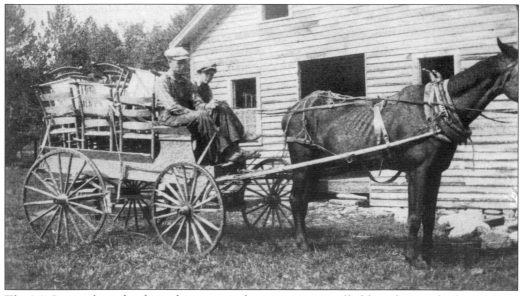

The McCarters brought their chairs to market in a wagon pulled by a hungry-looking horse. (Courtesy of Arrowmont.)

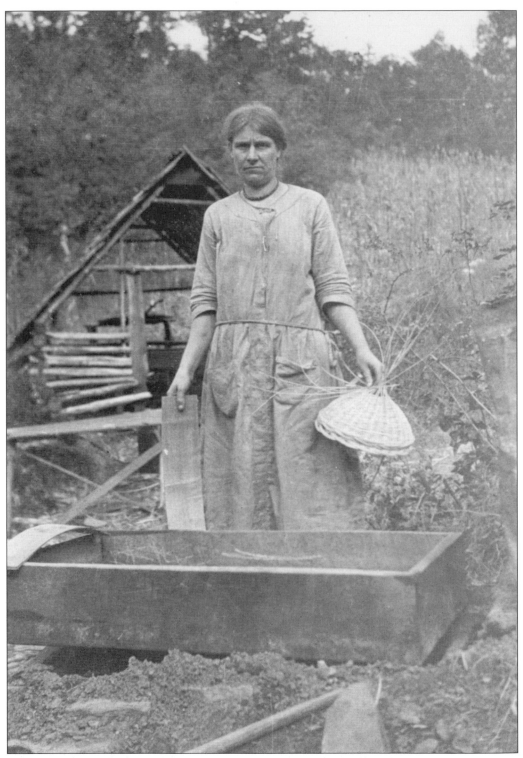

This picture shows Mary Ownby making baskets in what Laura Thornborough called a "home factory." (Courtesy of GSMNP.)

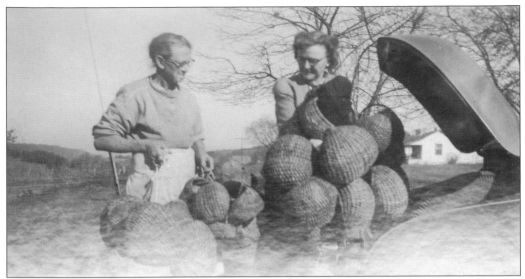

Eventually Aunt Lydia's baskets were delivered to the Arrowcraft Shop by car. (Courtesy of Arrowmont.)

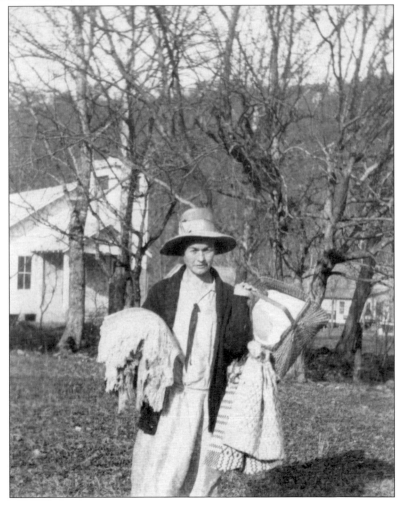

Izora Keener is shown here delivering her weaving to Pi Phi. On her way, she walked three miles and crossed Baskins Creek 17 times. (Courtesy of Arrowmont.)

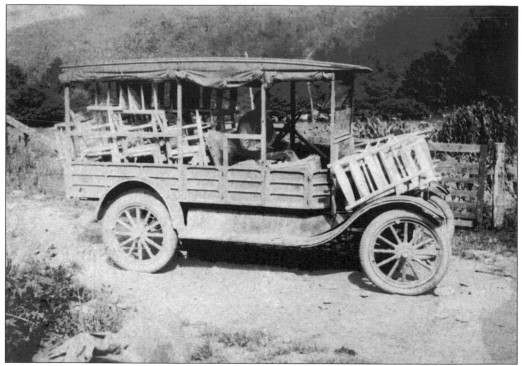

The contraption pictured here belonged to the Pi Beta Phi Settlement School and is being used to move an outgoing load of handmade chairs. (Courtesy of Arrowmont.)

The first stand-alone Arrowcraft Shop was opened in 1927 in the old school building in order to satisfy the demand for handmade products caused by increasing numbers of Gatlinburg's summer visitors. (Courtesy of Arrowmont.)

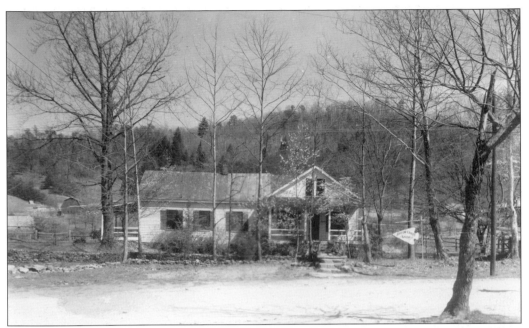

The Arrowcraft Shop was moved back from the road and an addition was built. Quilts and hooked mats were added to the weaving and baskets first sold in the shop. Soon furniture was added. (Courtesy of Arrowmont.)

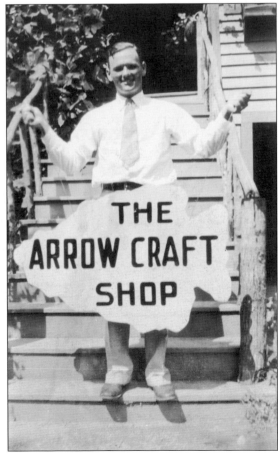

Charles Elliott, early Arrowcraft shopkeeper, is pictured with the store's first sign, which can also be seen at right in the photograph above. The arrow, first on the Pi Beta Phi pin, symbolizes a forward outlook, and "craft" stands for creative work done with the hands. (Courtesy of Arrowmont.)

The Pi Phi weavers, photographed in 1929, were formed in 1927 by Winogene Redding, who introduced regular "weaving meetings" and brought the group subjects and speakers on topics from butter making to piano playing. From this group the Gatlinburg Weavers Guild was formed in 1932 and began to sponsor community projects, such as the production *Store Britches*, a play by Lula Mae Ogle, who also wove "coverlids." Proceeds from the performances went to the Gatlinburg Public Library and the Red Cross. (Courtesy of Arrowmont.)

Four

LIFE IN THE 1930S AND THE EARLY CRAFT BUSINESS

In the early 1930s, enterprising local craftsmen, shopkeepers, and hoteliers used the lessons they had learned from the Pi Beta Phi Settlement School and the Arrowcraft Shop to bring about the next phase of Gatlinburg's history and development of a tourist economy. The boys of the Civilian Conservation Corps, highway workers, enthusiasts, and park personnel needed a place to stay and food to eat and more shops in which to buy local goods.

Gatlinburg became an example of a "build it and they will come" mentality while the rest of the country struggled through the Great Depression. This is not to say that Gatlinburg was wealthy, that would come later. Instead people who had been self-sufficient using a barter economy now also had cash to spend when the rest of the country was out of work and in soup lines.

People in the "Burg" went about the daily tasks of earning a living, going to church, visiting the local stores and post office, and burying their dead. The lumber industry would last into the 1940s. Visitors became residents, and residents developed new livelihoods. Subsistence farmers now made chairs, and mountain wanderers opened shops and music venues. Anna Wheaton Porter opened a library in her home. The town was booming, and soon there would be a national park.

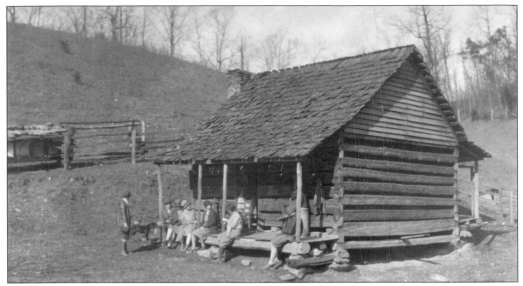

A building boom would come later, but in the meantime farm families began to convert cabins such as this one into tourist courts or rental houses for state highway workers. (Courtesy of Arrowmont.)

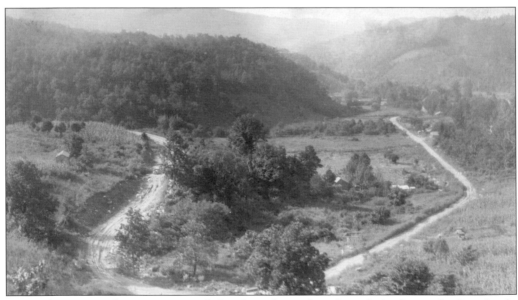

Later to become Highway 441 to North Carolina, the road on the right leads into the Sugarlands, where the national park headquarters are today, and on to Newfound Gap across the Great Smoky Mountains to North Carolina. Despite the increase in visitors, Gatlinburg in the early 1930s was still an empty, wide spot on a dirt road. (Courtesy of Arrowmont.)

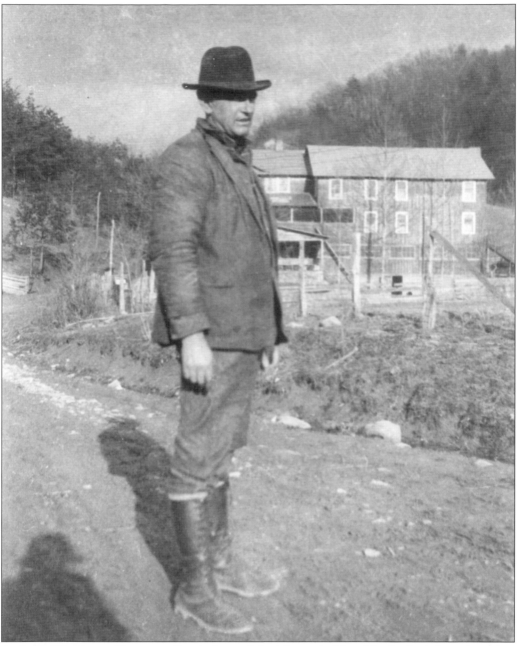

Andy Huff is pictured here standing in front of the Mountain View Hotel, which he enlarged in 1924 to accommodate the influx of visitors. A large dining room and kitchen were added with two stories of lodging rooms upstairs. (Courtesy of GSMNP.)

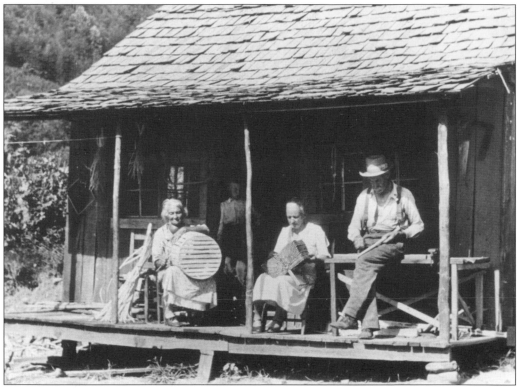

The entire McCarter family assisted in the production of baskets made of split white oak and worked from the porch of their cabin. (Courtesy of GSMNP.)

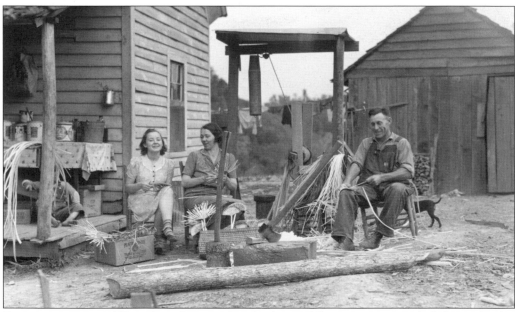

Summer tourists would have been happy to buy the fans and flyswats constructed of white oak splits that were made by the E.M. "Ken" McCarter family, pictured here. (Courtesy of Arrowmont.)

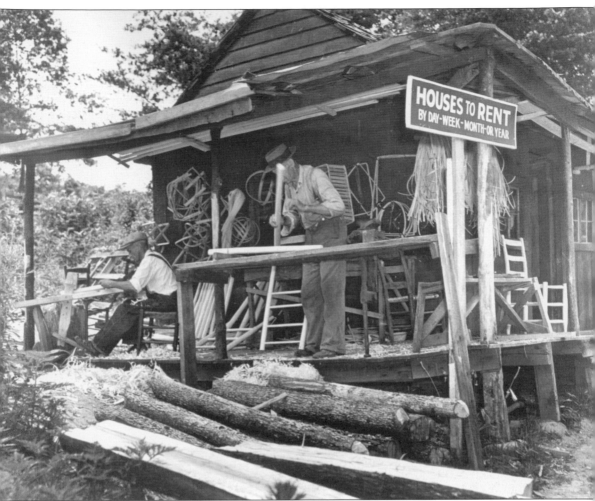

Mack McCarter learned to make chairs from his father, Fate. The sale of chairs and handmade baskets supplemented income from his small farm. McCarter also rented cabins for Ephraim Ogle. (Courtesy of McCarter-Soehn family.)

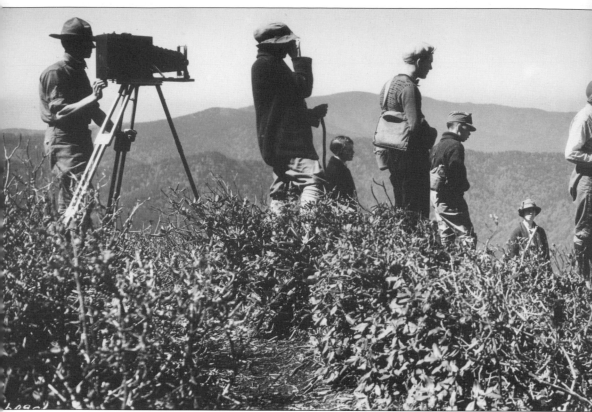

This large group of tourist/photographers exemplifies the many visitors to Gatlinburg and the mountains, once word spread that the area would be home to a new national park. In one year

These Rotary Club members were photographed on an outing into the mountains. (Courtesy

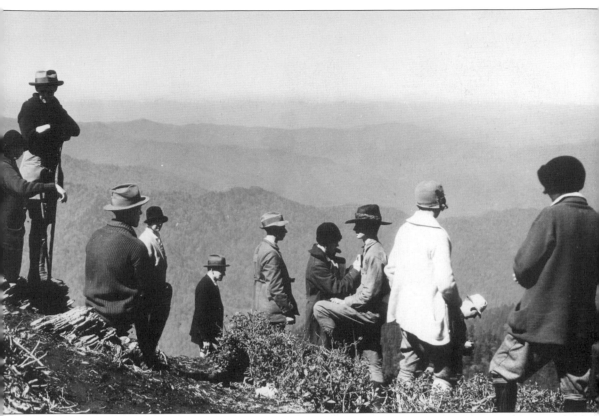

after World War II, the Great Smoky Mountains National Park welcomed over a million visitors. (Court of Thompson/McClung.)

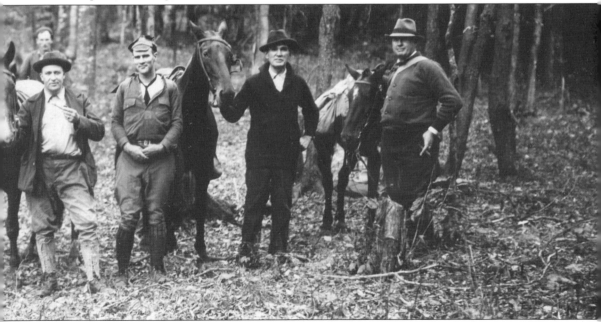

of Thompson/McClung.)

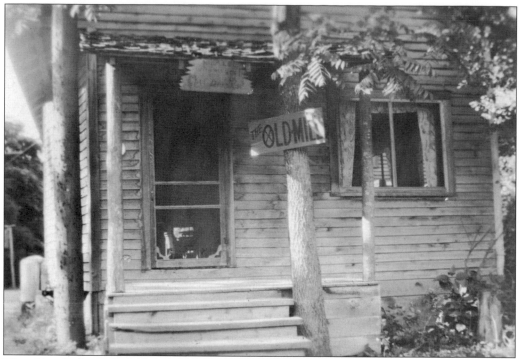

The old mill shown here was the site of the Cardwell Furniture Factory that was replaced in the 1940s by Zoder's Court. Wallace Zoder had come to Gatlinburg with the Civilian Conservation Corps in the 1930s. Each of the 14 units would have a fireplace, private bath, and porch over the water and rent for $2 per person. (Courtesy of the Zoder family.)

Shown here in a 1926 picture, the Swinky Café's existence proves that Gatlinburg was not without restaurants. Possibly this one was the first. (Courtesy of GSMNP.)

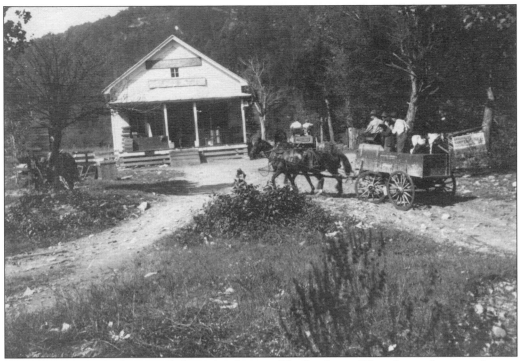

By the 1930s, E.E. Ogle's store belonged to his son Charles. Laura Thornborough wrote that no trip to Gatlinburg was complete without a visit to Charlie's store. Originally a "small single room cluttered up with all sorts of things," it became a "general store where you can still get more things for less trouble than you would have thought possible." (Courtesy of Bud Lawson.)

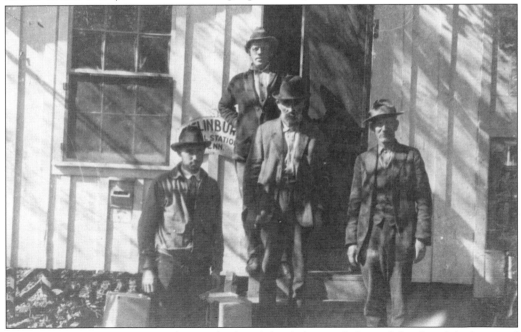

From left to right, Everett Trentham, Charles Clabo, Ephraim Ogle, and Crockett Maples stand in front of the Gatlinburg Post Office about 1926. (Courtesy of GSMNP.)

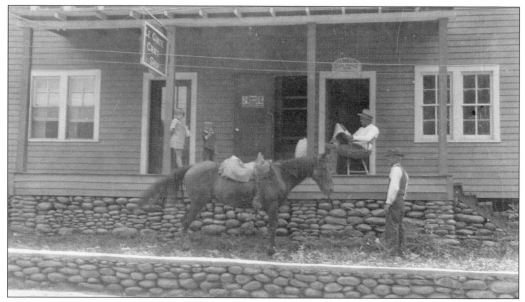

As the craft industry took off in the 1920s, the Squire Maples Building housed the Gatlinburg Post Office and the Le Conte Craft Shop, and horses were a useful form of transportation. Pictured here are, from left to right, Josie Maples, Squire Maples, and Crockett Maples. (Courtesy of GSMNP.)

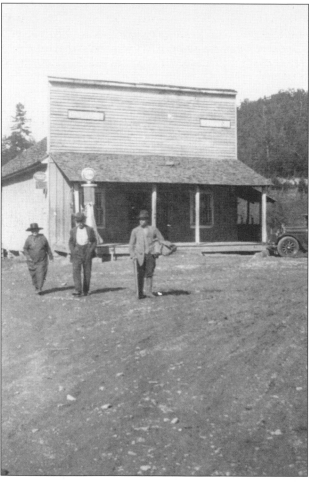

In this shot of Calvin Ogle's store from 1926, an early gas pump is visible behind the center walker. (Courtesy of GSMNP.)

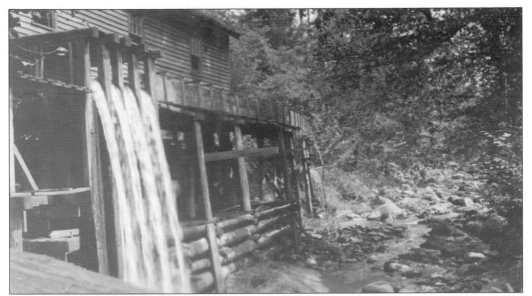

This old mill, sometimes called the Do Little Factory, once housed the Cardwell Furniture Factory, the first factory in Gatlinburg. It was located near the mouth of Roaring Fork Creek where Zoder's Court would be built. The "factory" was also used to grind corn and make coffins. When several coffins washed out in a flood, several shocked people downriver tried to save what they thought were bodies. Later, neighborhood children caulked the coffins with tar and paddled them down the Little Pigeon River. (Courtesy of GSMNP.)

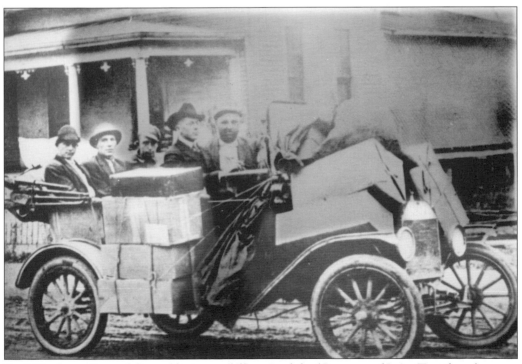

By 1930, the mail was delivered by a very full automobile. (Courtesy of JoAn Trentham.)

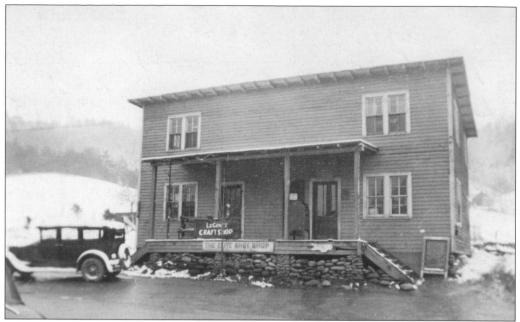

In the later 1930s, the post office shared its building with the LeConte Craft Shop and the Elite Shoe Shop and a car is parked out front instead of a horse. The building also housed Anna Porter's library at a later date and served as a bus station. (Courtesy of Wilma Maples.)

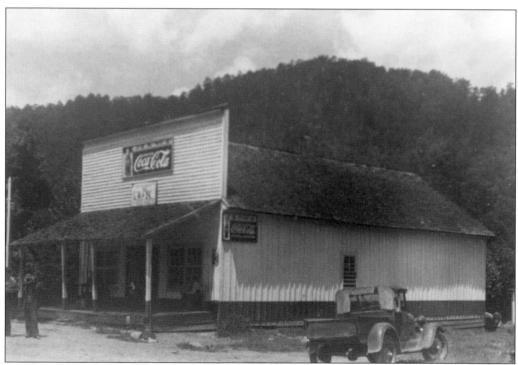

The J&K Store, seen in this 1930s photograph, had been the Calvin and Ashley Ogle store across from the Mountain View Hotel—where the Polly Bergen Shop and later the Carousel Mall would be located—at the intersection of Highways 321 and 441. (Courtesy of JoAn Trentham.)

The Conley Mill was located
on Roaring Fork Creek.
(Courtesy of JoAn Trentham.)

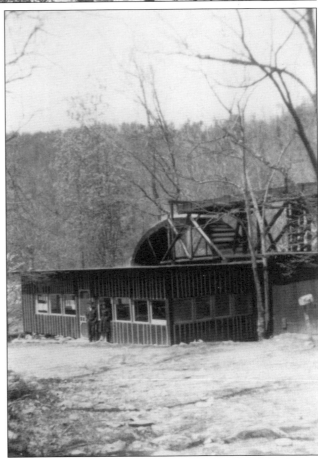

A.J. Ely managed the Water
Wheel Craft Shop, along with
the mill and a woodworking
shop, in the 1930s. The antique
shop on Roaring Fork Road is
now known as Ely's Mill and
is operated by "Old Man" Ely's
granddaughter. (Courtesy of
Ruth Sutton Wellborn.)

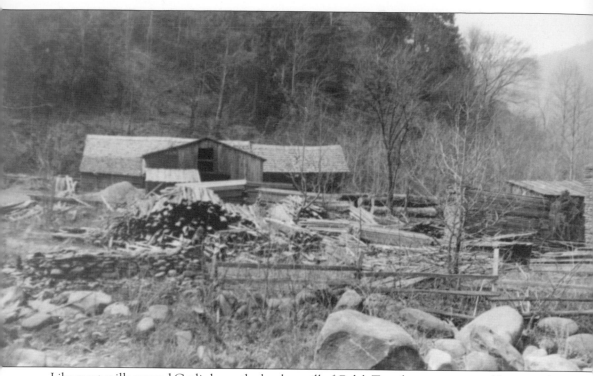

Like most mills around Gatlinburg, the lumber mill of Caleb Trentham was powered by using the force of the area's abundant water. (Courtesy of JoAn Trentham.)

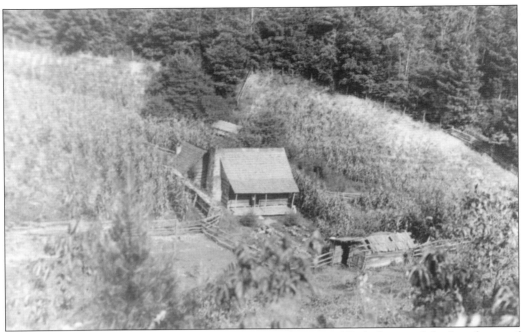

This 1933 aerial photograph shows the continued rural nature of Gatlinburg and the farm home of Uncle Tom and Aunt Sophie Campbell, which was located on Campbell Lead Road overlooking Gatlinburg. (Courtesy of JoAn Trentham.)

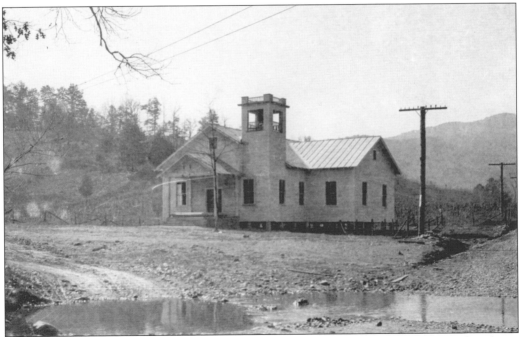

This is a view of the White Oak Flats Baptist Church in 1932, located on the corner of Highway 441 and Cherokee Orchard Road. (Courtesy of GSMNP.)

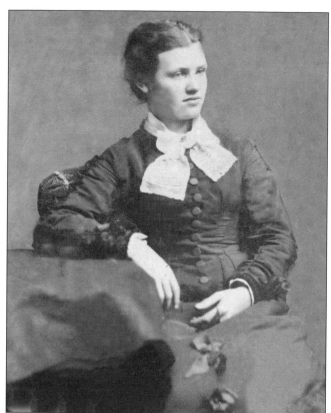

Anna Wheaton Porter, a transplant from Iowa, began Gatlinburg's first library in her cottage on Burg Hill in 1932. Writing to friends, she pleaded for them to "send me books for the children of Gatlinburg have none," a quote now mounted in the 2009 library building. (Courtesy of APPL.)

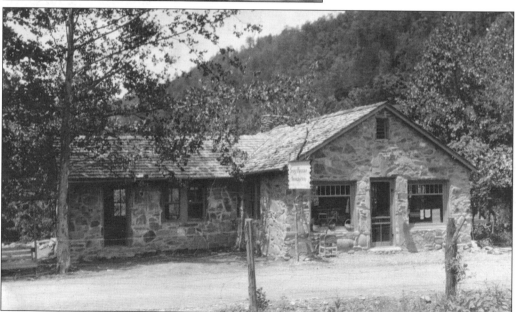

The Smoky Mountain Handcrafters, shown here, opened in 1925 and was run by Allie Reagan Ownby and her mother, Hurwitz Reagan. Later, Anna Porter's library moved from her house on Burg Hill to the back room on the left. The shop/library still stands as part of the building that housed Ruby Tuesdays restaurant. (Courtesy of Bud Lawson.)

Pictured here is Laura Thornborough, a Knoxville, Tennessee, native, world traveler, and motion picture industry pioneer, who wrote an early history of the area, *The Great Smoky Mountains*, in 1937. Her writing and her photographs did much to document Gatlinburg's history. (Photograph from a newspaper article taped inside a signed copy of Thornborough's book *The Great Smoky Mountains*.)

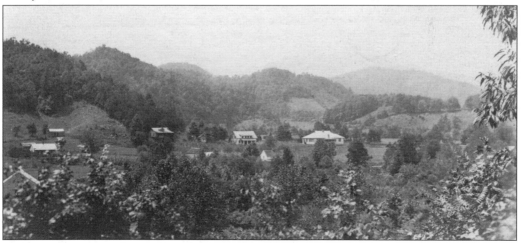

Author Laura Thornborough and a "fair-sized circle of friends," including author Jeannette Greve and librarian Anna Porter, lived in small cottages on Burg Hill, known earlier as Blockhouse Hill for the Confederate blockhouse fortified during the Battle of Gatlinburg. (Courtesy of Arrowmont.)

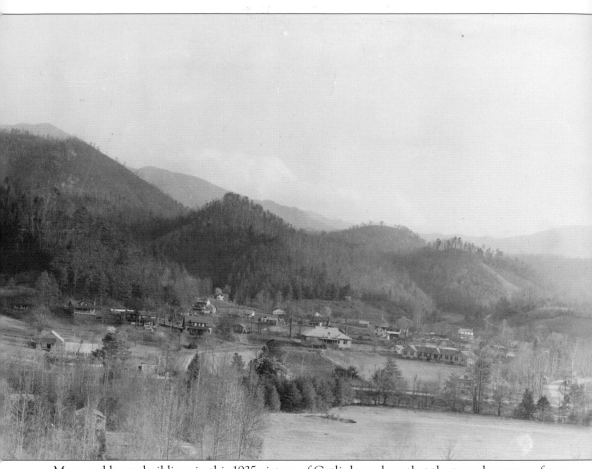

More and larger buildings in this 1935 picture of Gatlinburg show that the town has grown from a mountain village to a small town, thanks to the visitors coming to see the mountain scenery and purchase handmade craft items. (Courtesy of GSMNP.)

Five

EARLY TOURISTS COME FOR THE SCENERY AND HANDMADE GOODS

The Gatlinburg expansion had not relied on the craft industry alone. Talk of placing a national park in the Great Smoky Mountains next to Gatlinburg had begun in the 1920s. In 1933, Pres. Franklin Roosevelt pledged $1,550,000 "to complete the project." In 1934, the Great Smoky Mountains National Park was established. With President Roosevelt's visit to dedicate the park in 1940, Gatlinburg's transition from mountain village to tourist town was complete. Between 1930 and 1940, the town's population grew from 75 to 1,300 residents. In 1934, there were 93 structures, and in 1942, there were 641.

Developing a cottage craft industry was a good thing, but the possibility of having a national park in the backyard was something else entirely. Local entrepreneurs opened tourist courts and individual craft and candy shops. Gas stations sprang up, stores expanded, and larger hotels were built. There was even a lodge built at the top of Mount LeConte.

By the end of the 1930s, a travel description of the town focused on tourist sites, independent craft shops, and lodging instead of the Pi Beta Phi Settlement School. Simultaneously the school's emphasis on crafts had spread throughout the "Burg's" population. In 1937, the idea for a commercial arts and crafts community solidified along Glades Road to eventually become an established "driving trail" with brochures and maps. Creation of the arts and crafts loop, combined with the opening of the Buckhorn Inn, began to transform the Glades and Buckhorn Roads area from agriculture to tourism. The Gatlinburg Tourist Bureau opened in 1939, allied with the Gatlinburg Business Men's Information Bureau, and was replaced by the chamber of commerce in 1940. Gatlinburg was poised for even more growth, but World War II intervened.

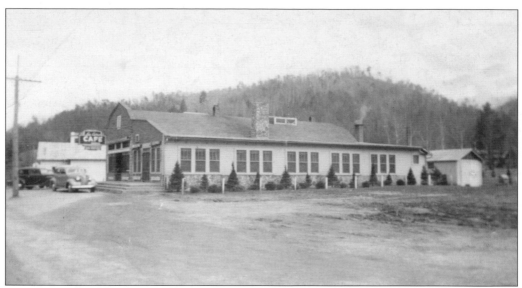

R.L. Maples built the Log Cabin Café around 1930. The Baptist church would have been to the left. (Courtesy of Wilma Maples.)

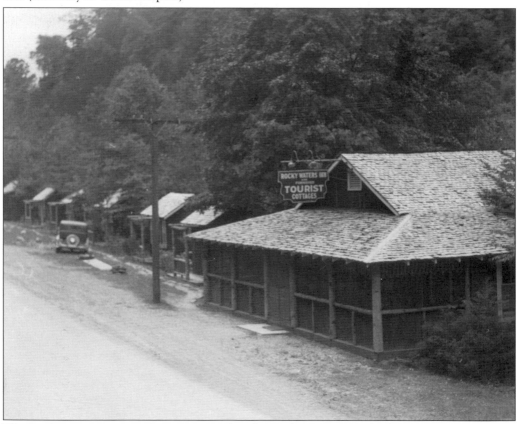

The Rocky Waters Tourist Cottages started as the Rocky Waters Inn, built in 1932 by a Mr. Fleck, and later bought and rebuilt by Andy Huff. Ralph and Mattie Lawson bought it in 1943, and their son Bud Lawson purchased it in 1971. (Courtesy of GSMNP.)

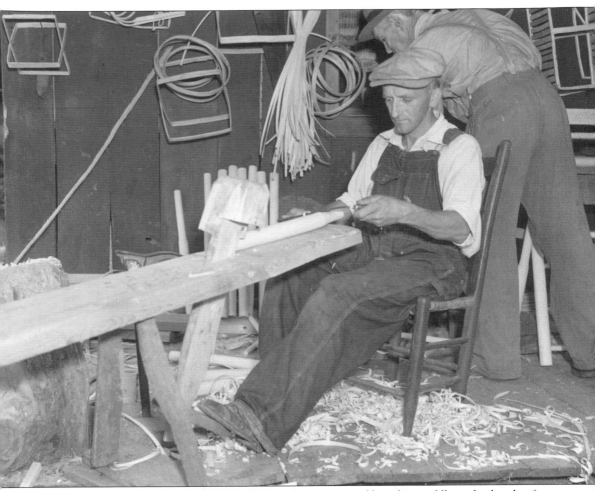

This picture shows Claude Huskey using a shaving horse operated by a foot peddle and a drawknife to make a chair at the Mack McCarter Shop. (Courtesy of GSMNP.)

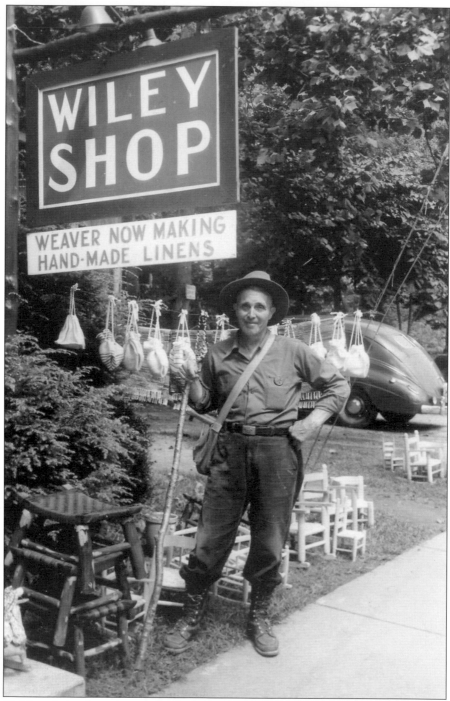

Wiley Oakley, shown here next to his Wiley Shop in 1937, was a self-styled "roamin" mountain man who guided visitors to hunt or fish in the mountains. He also performed with a mountain music band at his Wiley Shop and entertained with his own tales, later published in book form and sold. With 12 children to feed, Wiley and his wife, Rebecca Ann Ogle, who sold handwoven items in the shop, were industrious and enterprising.

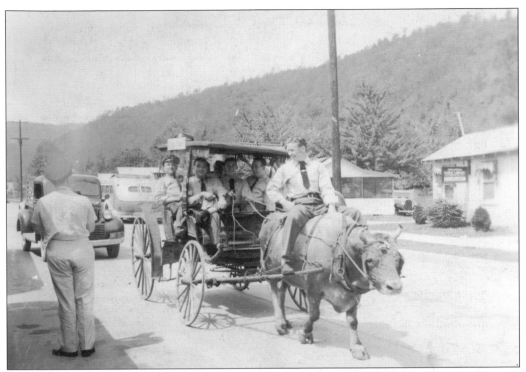

This picture of a tourist carriage pulled by an ox shows that the local people were not opposed to capitalizing on their "mountain folk" image. Interestingly, the ox rider is wearing a tie. (Courtesy of Bud Lawson.)

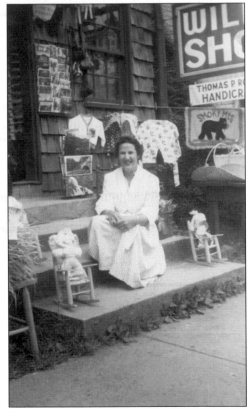

A shop clerk sits on the front porch of the Wiley Shop amid all sorts of handcrafted items that are for sale. (Courtesy of Blouin/APPL.)

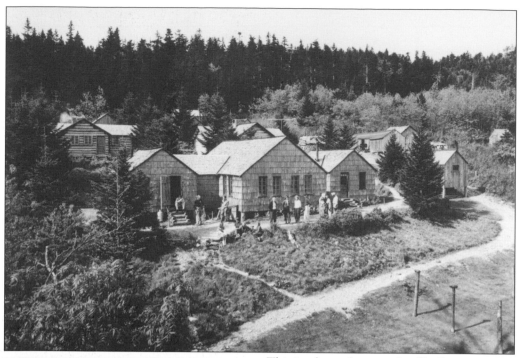

This is a later photograph of LeConte Lodge that was built at the top of Mount LeConte by Jack Huff, son of lumberman Andy Huff. At first this "smallest hotel in the world" had two cabins and a mess hall. (Courtesy of Charlynn Maxwell Porter.)

Martha Whaley Huff appears somewhat anxious as her son Jack prepares to carry her up to LeConte Lodge in a chair. Custodian Huff said in 1936 that 10,000 people climbed to the summit lodge, the only mountaintop inn in the new national park. (Courtesy of Bud Lawson.)

This 1977 photograph shows Winogene Redding, Lucinda Ogle, and Marjorie Chalmers, who formed the Gatlinburg Garden Club from the Weaver's Guild in 1937. (Courtesy of the Gatlinburg Garden Club.)

Pictured here are Dick Whaley, Jerry McCutchan, Andy Huff, Herbert Holt (city manager), R.L. "Rell" Maples, and Bruce Whaley, who formed the first Hotel-Motel Association in the late 1930s with four hotels and eight tourist courts. (Picture from the First National Bank 40th Anniversary book.)

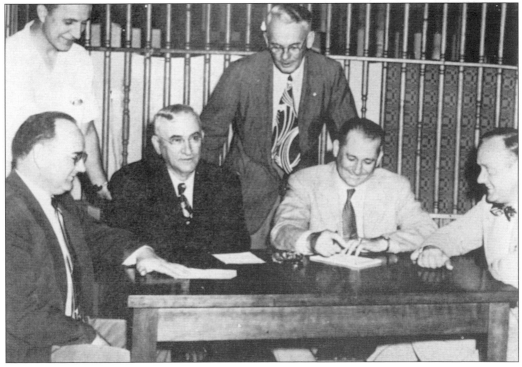

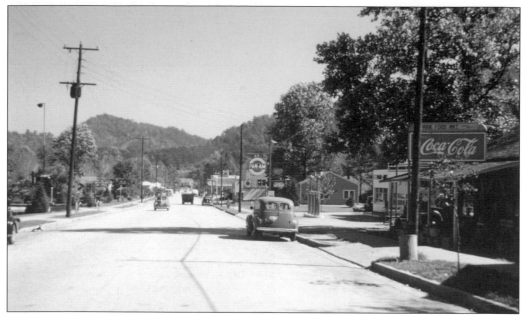

As the 1930s came to an end, paved streets, cars, and electric poles were evidence that Gatlinburg had entered the modern age. (Courtesy of Wilma Maples.)

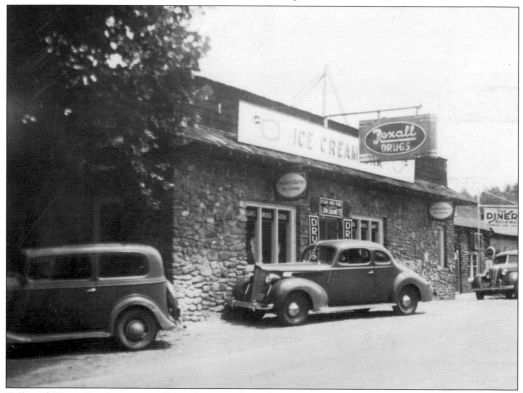

Bill and Katy Steele operated Steele's Sundries, located on the site of the earlier Hyam's Drug Store, from 1940 to 1955. It also served as a luncheonette, ice cream bar, and a place for tourists to buy postcards. (Courtesy of Wilma Maples.)

Hubert Bebb was a Gatlinburg architect with modernist ideas, known for his steep overhanging rooflines and the use of regional materials in his designs. Besides the Buckhorn Inn, Bebb designed the 1955 Mills Auditorium of the Gatlinburg Convention Center, the Clingman's Dome overlook, and the 1982 Knoxville World's Fair Sun Sphere. (Courtesy of Lee Mellor.)

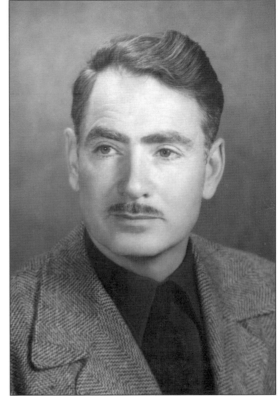

The Buckhorn Inn was founded in 1938 by Douglas Bebb and designed by his brother Hubert Bebb. Since its opening until today, the inn has provided such visitors as Walt Disney, Patricia Neal, and Tipper Gore a chance to retreat from everyday life and enjoy the view of Mount LeConte in the Great Smoky Mountains National Park. (Courtesy of Lee Mellor.)

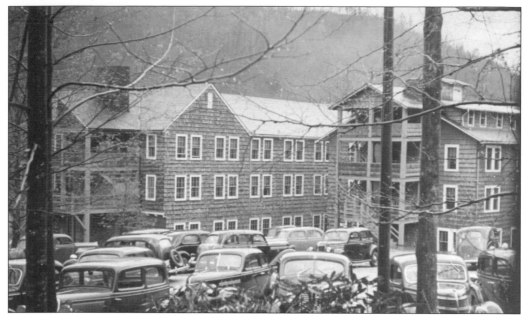

The Mountain View Hotel was built in 1930 with a large lobby porch and "modern" rooms offering steam heat to accommodate the tourists. Eight years before the National Park Headquarters Building was completed in 1940, park headquarters operated from cottages on the grounds of the Mountain View. The first park superintendent, Maj. J. Ross Aiken, lived in a new home also on the grounds of the hotel. (Courtesy of GSMNP.)

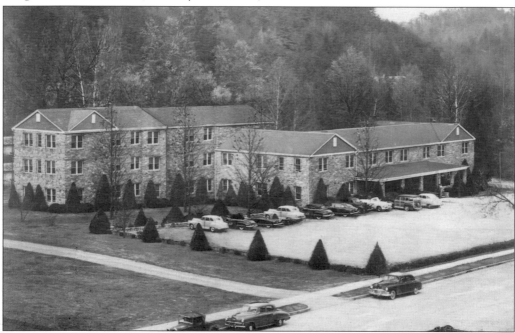

The Riverside Hotel was built in 1937 by Steve Whaley with wood from the old Indian Gap Hotel that had been located in the national park. It had begun as a 20-room boardinghouse where one could stay for $35 a month, including meals. Later, the hotel was rebuilt to face the new road—Highway 441—now called the Parkway. (Courtesy of Bud Lawson.)

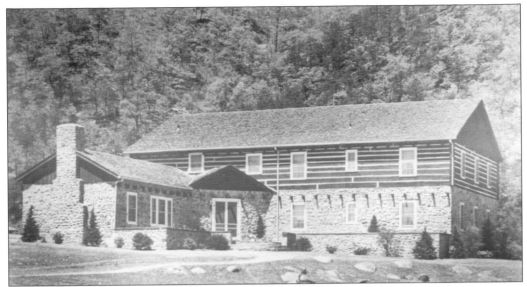

The Gatlinburg Inn, pictured as it looked in 1938, was built by R.L. Maples and continues as a hotel in 2011, managed by his widow, Wilma. (Courtesy of Wilma Maples.)

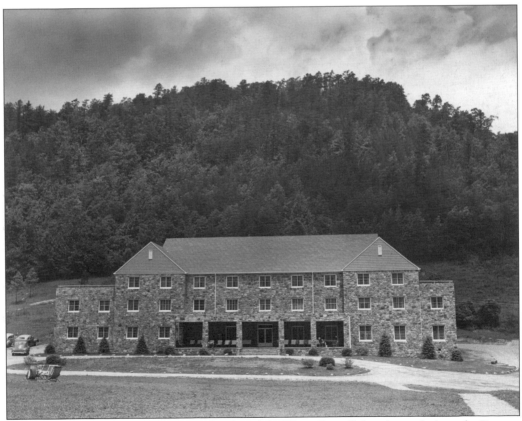

Steve Whaley's son Dick, who had also developed the Water Cress Cabins located where the Reagan Terrace Mall would be constructed later, built the Greystone Hotel. (Courtesy of TSLA.)

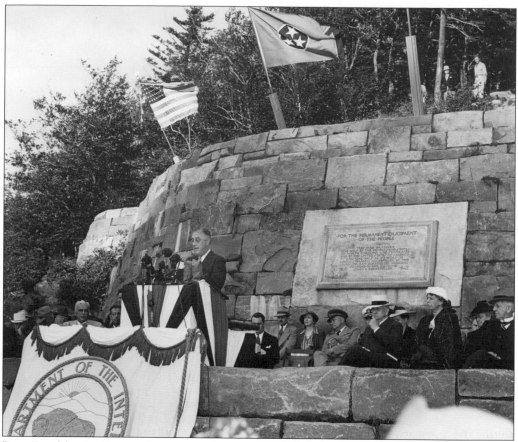

Pres. Franklin D. Roosevelt is shown here at the dedication of the Great Smoky Mountains National Park in 1940. At that time, the world was poised for war and Gatlinburg was poised to become a major tourist destination. (Courtesy of TSLA.)

The Great Smoky Mountains National Park, with its headquarters at Gatlinburg, is the most visited national park in the country. (Courtesy of GSMNP.)

Six

TAKING THE IDEA AND RUNNING WITH IT

During the war years, tire and gasoline rationing affected Gatlinburg, as it did the rest of the country. The town's visitation was at its lowest in 1943 with only 383,000 people. Happily, once the war ended, the tourists returned, and in 1946, visitation again topped one million.

According to Carroll Van West, by 1945, the year Gatlinburg was incorporated as a city, it had grown from a mountain town to a well-known resort town with modern tourist courts, handicraft shops, four large hotels, neon signs in profusion, and even "a great amount of 'cheap, gaudy' merchandise taking up shop space." Everywhere nylon handbags made of parachute material were sold. The T-shirt shops would come later.

As its economy grew and the area became even better known, Gatlinburg remained unique. Instead of incoming corporations and wealthy newcomers, the local families, mainly descendants of the original settlers, maintained control on all the property and began to reap the financial rewards.

As more working craftsmen opened their homes and shops along Glades Road, the Pi Beta Phi Fraternity brought interested visitors to the "Glades" to meet the craftspeople and see where and how they worked. The Pi Beta Phi Settlement School stepped up its adult education program, and the Pi Beta Phi Summer Craft Workshops began. The first craft fairs were an outgrowth of those workshops as the fairs gave both teachers and students an opportunity to display their art and their crafts. Until 1970, the Pi Beta Phi Settlement School also functioned as the Pi Beta Phi Summer Crafts Workshop.

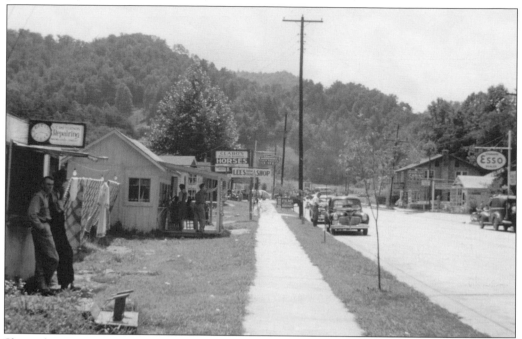

Shown here is a 1940 view of Gatlinburg going south into town. Today, the Crossroads Motel is on the left instead of Clabo's Horses, and the building that housed the Smoky Mountain Handcrafters and Ruby Tuesdays is to the right of the Esso station. (Courtesy of Wilma Maples.)

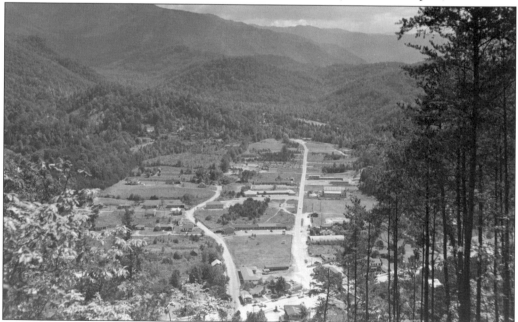

Airport Road, on the right, was named for the airport field owned by Isaac L. Maples and developed for commercial sightseeing from the air before World War II. Demand for land after the war caused the runway to become a road. Two planes were based there before the war and were used to fly above the parkway at low altitudes announcing "Come fly with us—it's 20 degrees cooler up here" or "Eat at the Fox Restaurant where you will find the food excellent." (Courtesy of Wilma Maples.)

Shown here is a view of the corner of Roaring Fork Road, later Highway 321 and Highway 441. Automobiles are prevalent, but nowhere near as plentiful as they would become. (Courtesy of Frances Fox Shambaugh.)

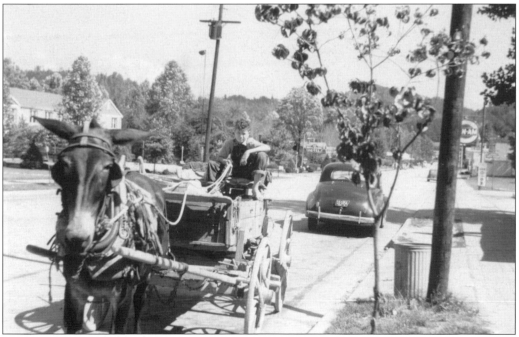

In the early 1940s, the streets were still empty, and cars coexisted with mules and wagons. Visitation was its lowest ever in 1943, when only 383,000 people came to town. (Courtesy of Wilma Maples.)

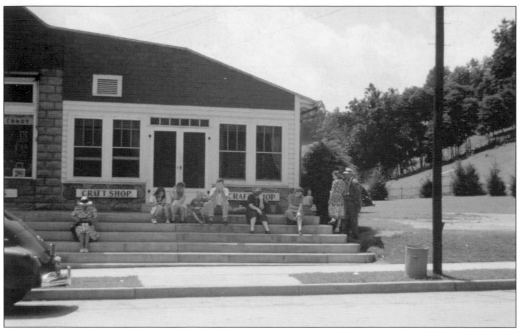

In the 1940s, the building housing the Le Conte Craft Shop and the Log Cabin Café also functioned as the bus station. (Courtesy of Wilma Maples.)

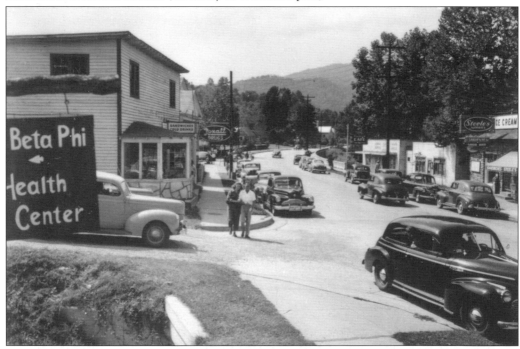

In the 1940s and 1950s, the building on the left across the street from the health center sign was home to the Smoky Mountain Handweavers, and a woman demonstrating weaving would have been in the protruding front window. The number of street and front window craft demonstrations gave the impression that downtown Gatlinburg had many more craft shops than it really did. (Courtesy of Charlynn Maxwell Porter.)

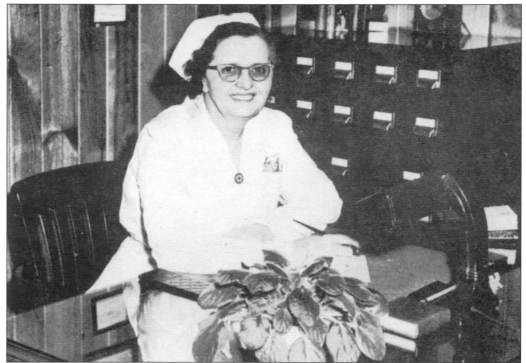

Marjorie Chalmers became the Pi Beta Phi Settlement School nurse in 1935. By 1965, the area had many doctors and the health center closed. The building became the office for the Arrowmont School of Arts and Crafts. (Photograph from *Better I Stay* by Marjorie Chalmers.)

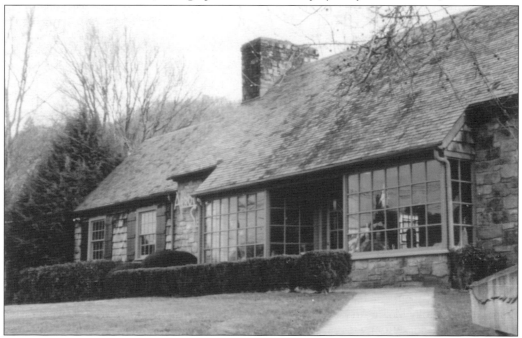

The Pi Phis constructed a new building to house the Arrowcraft Shop in 1940. (Courtesy of Arrowmont.)

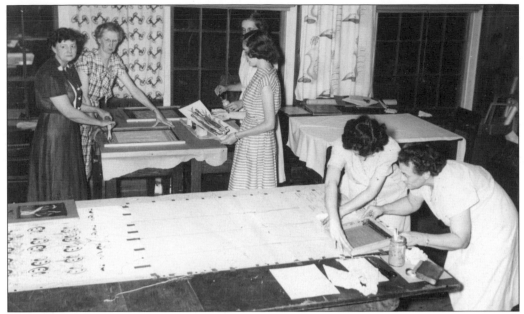

Shown here are women screen printing in the 1940s. In 1945, the Pi Phis developed the Pi Beta Phi Summer School of Crafts in conjunction with the University of Tennessee, with Marian Heard as director. After the county took over support of Gatlinburg schools in 1965, the Pi Phis then morphed the Summer School of Crafts into Arrowmont School of Arts and Crafts. (Courtesy of Arrowmont.)

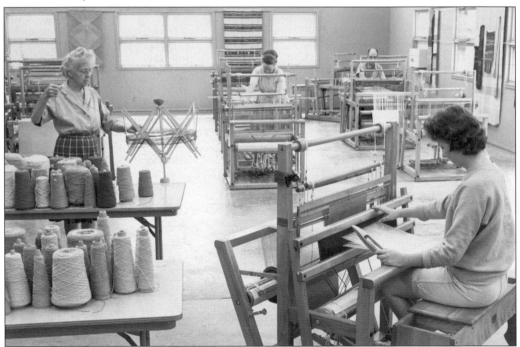

This photograph provides a view of the Pi Phi Weaving Room. Nancy Huff Hays wrote that the Arrowcraft Shop elevated the traditional craft (weaving) to an art. By 1962, seventy-three weavers would be bringing their products to Arrowcraft. (Courtesy of Arrowmont.)

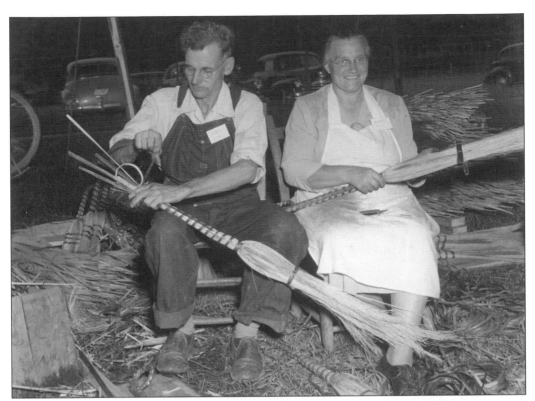

Mr. and Mrs. Elmer Kear demonstrated their craft of broom making at early craft fairs. (Courtesy of SHCG.)

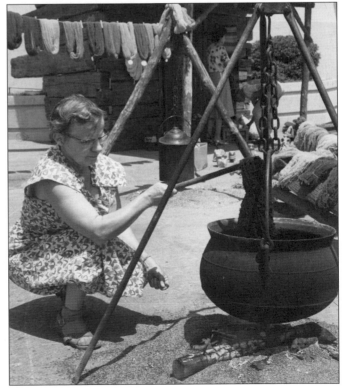

Mary Frances Davidson is shown here dying wool in the 1940s, probably at a craft fair. Natural dyes required specialized knowledge and usually raised a product's price beyond what would easily sell. Davidson's recipe for dyeing one pound of wool included "Barks-one peck finely chopped. Flowers-one and one-half quarts, dried flower heads; one and one-half pecks fresh flower heads." (Courtesy of SHCG.)

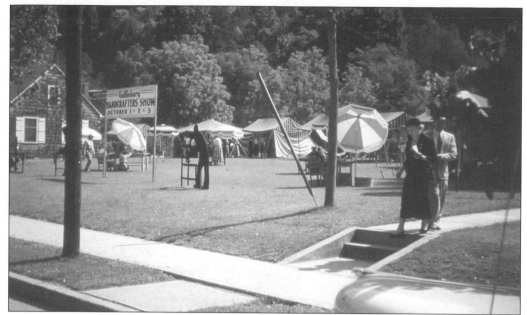

The Gatlinburg Handcrafter's Show was held in 1947 in tents on the grounds of the Pi Beta Phi Settlement School. The first fairs were held in conjunction with the end of term at the Pi Beta Phi Summer School of Crafts and provided a chance for potential buyers to view crafts and demonstrations by the teachers and their students, many of whom were also residents of Gatlinburg. (Courtesy of SHCG.)

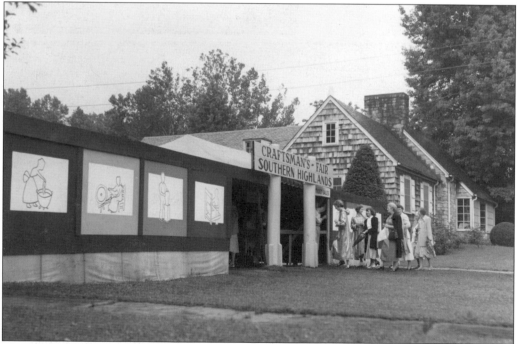

The first Southern Highlands Craftsman's Fair was held in 1948 and was sponsored by the Southern Highlands Handicraft Guild. This picture shows the entrance to the 1950 Craftman's Fair. (Courtesy of Arrowmont.)

In this picture, Matt Ownby is fashioning a bowl from wood at a craft fair demonstration. (Courtesy of SHCG.)

This 1945 photograph shows the first McDonald Pottery, located on the Parkway across from where Rocky Waters is now. Kennedy and Barbara McDonald later moved their business to Buckhorn Road and were instrumental in developing the Arts and Crafts Tour on Buckhorn Road and Glades Road. (Courtesy of Bruk McDonald.)

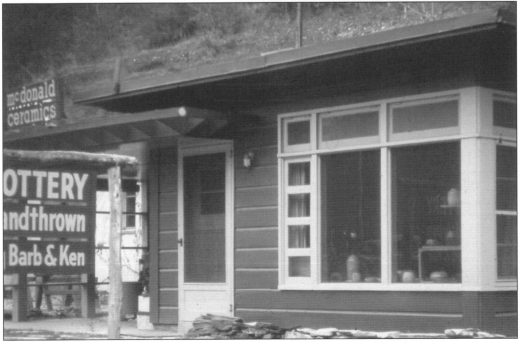

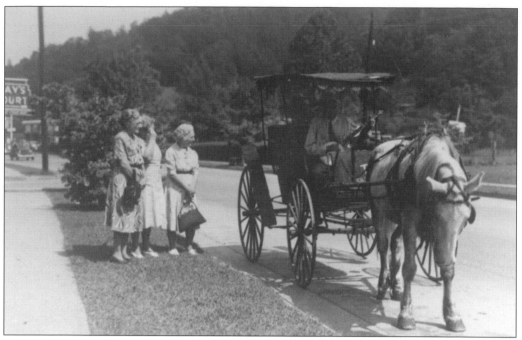

This 1947 photograph demonstrates that even though the roads were paved and cars were prevalent, a "surrey with the fringe on top" would provide local color and a bit of income, hopefully to feed the poor horse. (Courtesy of JoAn Trentham.)

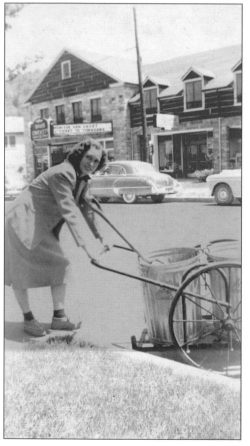

If horses are around pulling surreys, then a scooper-upper is needed to clear the streets of horse debris. The David Crockett Theater can be seen in the background. It was included in the Maples Building storefronts along with the new First National Bank, Denton Drug Store, and Trout Hardware. (Courtesy of Janis Frederick.)

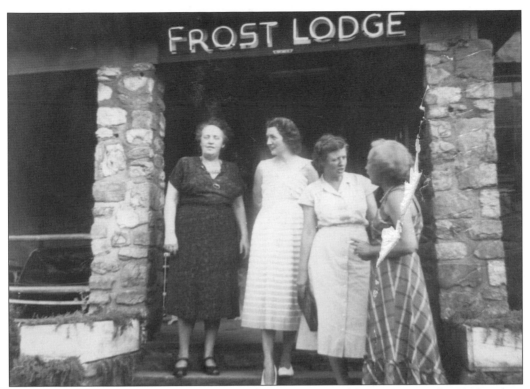

Pictured here is Frost Lodge, previously Wood's Lodge, managed by Ina Frost in the 1940s, when breakfast cost 50¢ and up and dinner was $1.50. Edna Lynn Simms's Smoky Mountain Museum would have been to the right and Airport Field back and left. (Courtesy of Charlotte Connor.)

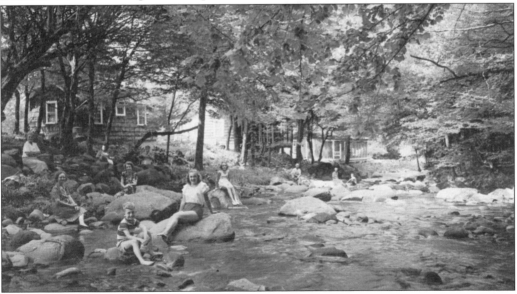

Visitors staying at Cox's Brookside Cabins are enjoying the Roaring Fork Creek. According to a "List of Accommodations" from the 1940s, these cabins rented for $1.50 and $2 per person and featured electric stoves, hot water heaters, and innerspring mattresses. By 1949, Gatlinburg could sleep 5,000 people, up from 1,200 before World War II. (Courtesy of Frances Fox Shambaugh.)

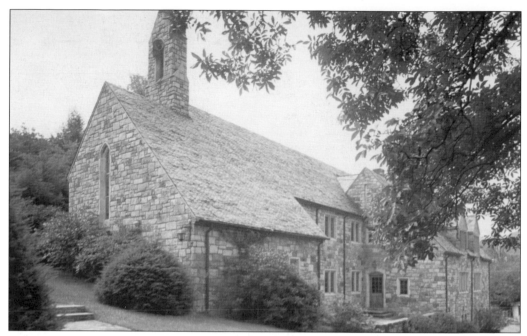

The Gatlinburg First United Methodist Church features lighting fixtures designed by artist Louis Jones and pews designed and built by wood craftsman J.C. Cole and his wife, Eunice. The first service held at this church building was on April 6, Easter morning, 1947. Artist Louis Jones donated the land on which the church would be built. Seasonal visitors to Gatlinburg were instrumental in founding the Methodist congregation. (Courtesy of First Methodist Church.)

Louis Jones, who moved to Gatlinburg from Woodstock, New York, in 1933, was one of the first of Gatlinburg's year-round resident artists who moved into the area from afar. (Courtesy of First Methodist Church.)

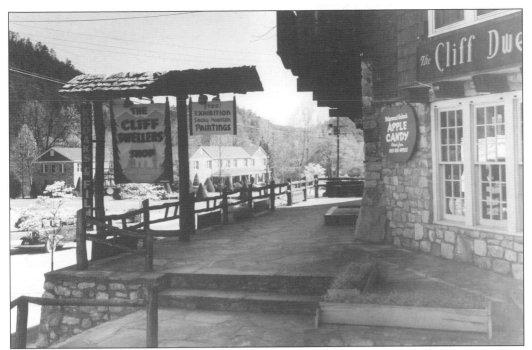

In the 1930s, Louis Jones built the Cliff Dwellers Shop, seen here as it looked in 1949, using 20-foot-long hand-hewn American chestnut beams. The Cliff Dwellers was a downtown landmark until 1995, when artist Jim Gray and his son Chris moved the building to a site on Glades Road. The shop is now owned and operated by a consortium of local artists. (Courtesy of TSLA.)

E.L. Reagan was photographed whittling on the bridge to his wood working shop situated on Roaring Fork Creek. (Courtesy of First Methodist Church.)

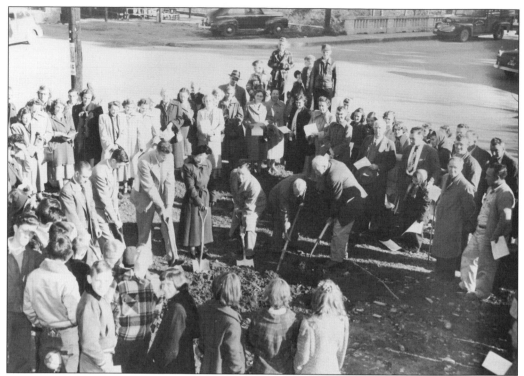

Members of the First Baptist Church congregation join forces to dig for placement of the cornerstone of the church to be built, once again, on the corner of Cherokee Orchard Road and the Parkway across from the Arrowcraft Shop. (Courtesy of First Baptist Church.)

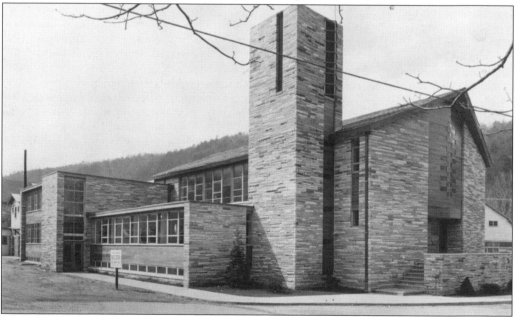

This is a picture of the First Baptist Church built in 1949. A new church would be built on Highway 321, called the East Parkway. The building that replaced the church housed the Coffee Loft and later a Subway food shop. (Courtesy of Blouin/APPL.)

Seven

Gatlinburg Becomes a Major Tourist Attraction

Throughout the United States, the 1950s became the golden age of American vacations, and Gatlinburg was no exception. The new city's people embraced the opportunities that America's traveling middle class would provide. A more sophisticated city management improved public services and facilities. A sewage plant was built, garbage collection initiated, streets named, and traffic lights installed. A city advertising department was created, and the chamber of commerce that had faded away in the war years was reinstated with a professional manager.

The main street through town, Highway 441 across the mountains, was still known as Main Street but was four-laned and given grass and sidewalks and later renamed the Parkway. The old Roaring Fork Road, which connected to Glades Road and on toward Cosby, had become Highway 73. Later, it would be straightened, leveled by digging it deeper, becoming Highway 321 and eventually the East Parkway.

To save people having to carry that cash they were making all the way to Sevierville, the First National Bank was established. The town built an auditorium, a convention center, and a golf course. Individuals expanded their shops, provided street entertainment, built a professional theater, and a space needle. Gatlinburg even sent a motorcade of 15 cars with a highway patrol escort to spread the word of "mountain hospitality" and "cool mountain air" throughout the Deep South.

The Pi Beta Phi Settlement School received funds from the Sevier County School Board for basic education, and the Pi Beta Phi Fraternity funded extra classes in arts and crafts and home economics. With the presence of the Pi Phi teachers, the national park personnel, the unusual educational opportunities provided by the Pi Beta Phi Settlement School, the influx of cash, and visitors, Gatlinburg became even more "not your ordinary small mountain town."

Dick Whaley, R.L. Maples, and W.L. Mills were three of the original directors of First National Bank, which opened in 1951. Before a bank opened in Gatlinburg, daily deposits for the grocery store were sent to the Bank of Sevierville by the bread delivery man, and hotel owner Dick Whaley took other people's deposits to Sevierville along with the his hotel's deposits. (Photograph from First National Bank 50th Anniversary book.)

St. Mary's Catholic Church was built on Airport Road Motor Nature Trail in the 1950s to accommodate the religious views of visiting Catholics, as well as newer residents of Gatlinburg. (Courtesy of Blouin/APPL.)

Trinity Episcopal Church's first service was held in 1950. Trinity was built to serve the increasing number of travelers and the growing, religiously diverse population. The Cherokee masons who crafted its stonework left their signature in the form of an arrow in the floor of the church portico. (Courtesy of Trinity Episcopal Church.)

Gatlinburg Tourist Court was built on rare flat land at the south end of town. (Courtesy of Thompson/McClung)

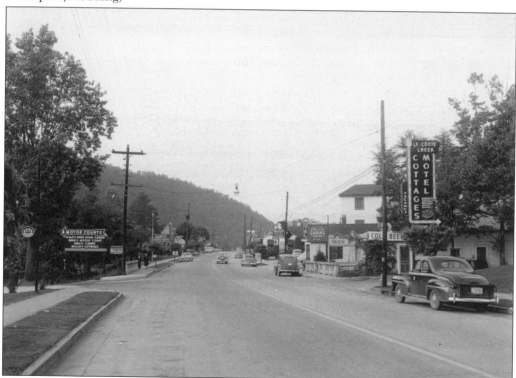

In this picture of the of the upper Parkway going north from the park entrance, Huff's Motel is now located on the left where the Motor Courts sign is, and Howard's Restaurant is past the LeConte Creek Motel. (Courtesy of GSMNP.)

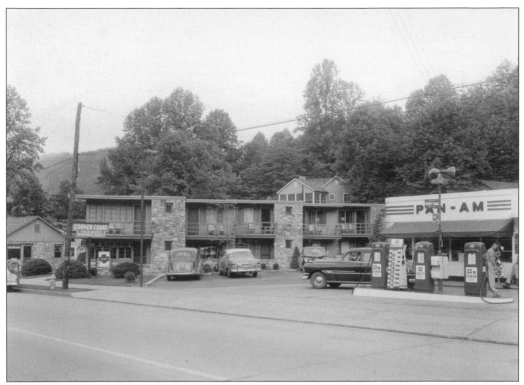

In 1952, Cooper Court and the Pan Am service station were on the Parkway with Houser's Grocery and Whittle's Drug Store to the right of Pan Am. This is now Reagan Mall with a miniature golf course behind it. (Courtesy of GSMNP.)

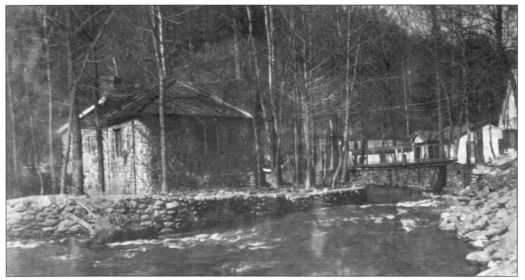

In the 1940s, Pleasure Island had cabins to accommodate up to 14 people, with kitchens as well as electric heating and fireplaces, and cost $1.50 per person and up. Amos Fox bought them from the Pierce King family in 1948. After the 1951 flood, they were sold to "Coot" Ogle who raised the island four feet and built Twin Islands Motel, which still floods on rare occasions. (Courtesy of Frances Fox Shambaugh.)

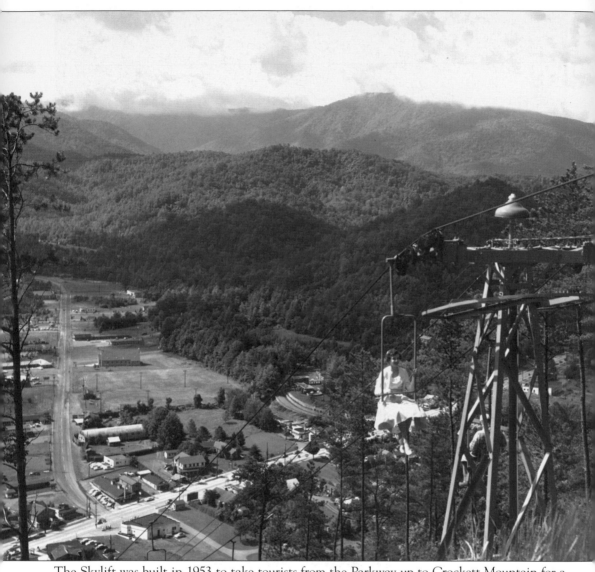

The Skylift was built in 1953 to take tourists from the Parkway up to Crockett Mountain for a view of Gatlinburg and panorama of the Great Smoky Mountains. (Courtesy of TSLA.)

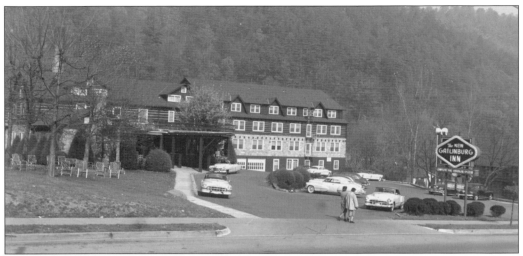

The New Gatlinburg Inn added a heated swimming pool and telephones in its rooms in 1951. The Greystone, Mountain View, and Riverside hotels followed suit and put in telephones as well. The inn's owner, R.L. Maples, leased land next to his hotel to John and Everett Kirchner from Michigan on which to put the Skylift. (Courtesy of Wilma Maples.)

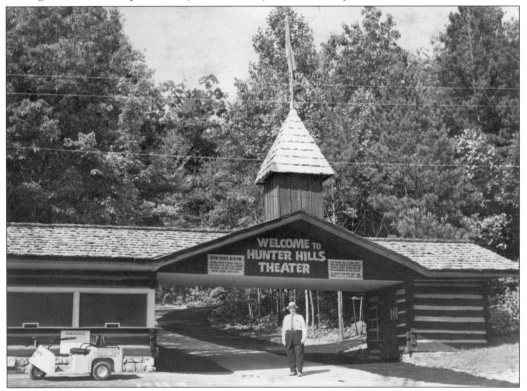

Hunter Hills Theater was an open-air venue situated where the high school baseball field is now located near the Gatlinburg Community Center and the public library. The theater was built by R.L. Maples and named for Kermit Hunter, who wrote *Chucky Jack*. Featuring 15 actors and a full production staff, *Chucky Jack* told the story of the first governor of Tennessee, John Sevier. (Courtesy of Wilma Maples.)

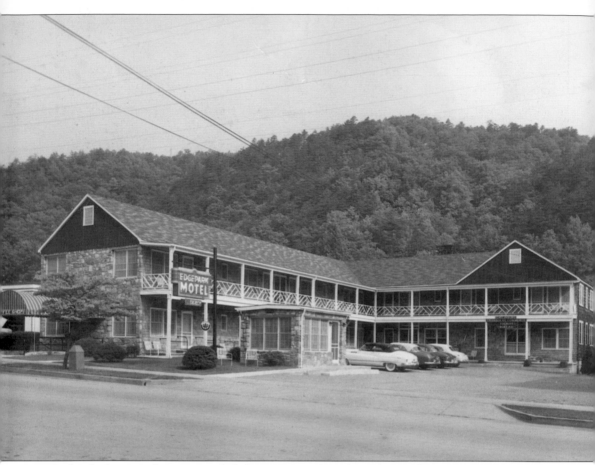

Individual air-conditioners cooled the rooms at the Edgepark Motel in 1954. Around the same time, motel owners installed carpeting and private tubs or showers and paved their parking lots. (Courtesy of Bud Lawson.)

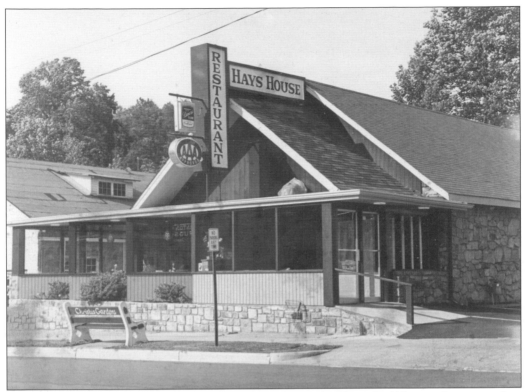

The Hays House Restaurant that offered family-style dinners had been Carl Newman's supermarket. (Courtesy of Jerry and Nancy Hays.)

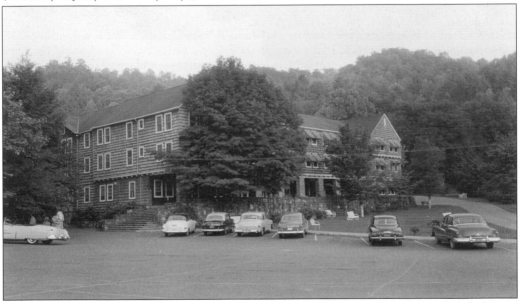

This is a 1952 picture of the Mountain View Hotel. Over the years, noted visitors included Eleanor Roosevelt, as well as Ken Curtiss and Milburn Stone from the long-running television show *Gunsmoke*. In 1951, Gatlinburg hosted the 43rd Annual Governor's Conference and the Mountain View hosted a dinner for 500 people. (Courtesy of GSMNP; photograph by Abbie Rowe.)

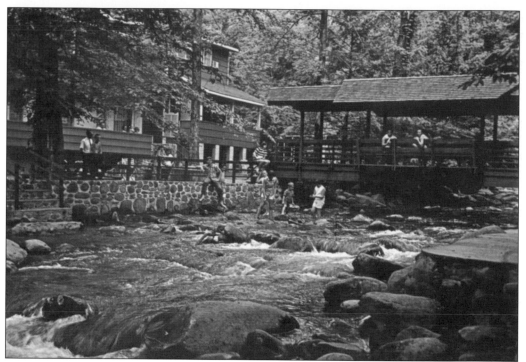

Carr's Northside Cottages were built along Roaring Fork Creek, now Highway 132 or East Pakrway. (Courtesy of Blouin/APPL.)

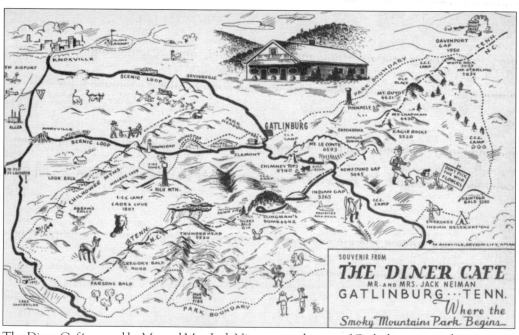

The Diner Café, owned by Mr. and Mrs. Jack Nieman, used a map of Gatlinburg as an advertisement in the 1950s. (Courtesy of Blouin/APPL.)

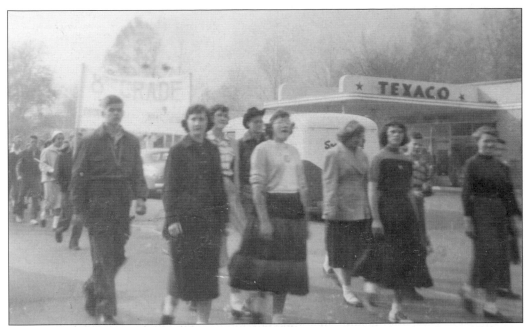

In the 1950s, Pi Beta Phi High School students marched to raise funds for band uniforms. (Courtesy of Frances Fox Shambaugh.)

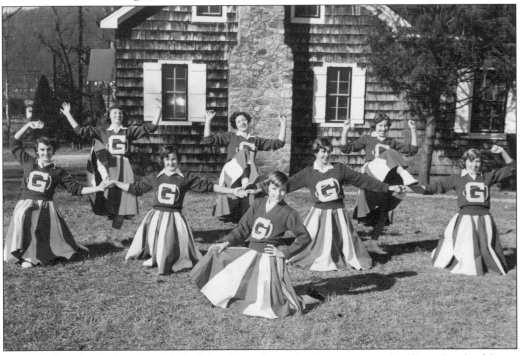

Cheerleaders for Pi Beta Phi High School are shown here outside the building that had been a church, then the original Pi Beta Phi Settlement School, the Arrowcraft Shop, and now the Thomas Kinkade Gallery. The 1929 building that served as a combined elementary and high school was replaced when Sevier County built the Pi Beta Phi Elementary School in 1965. (Courtesy of Frances Fox Shambaugh.)

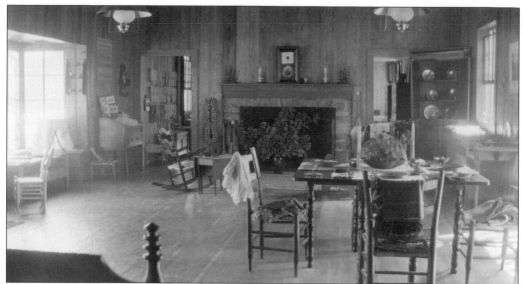

In the 1950s, handmade furniture was added to the locally made items sold at the Arrowcraft Shop. (Courtesy of Arrowmont.)

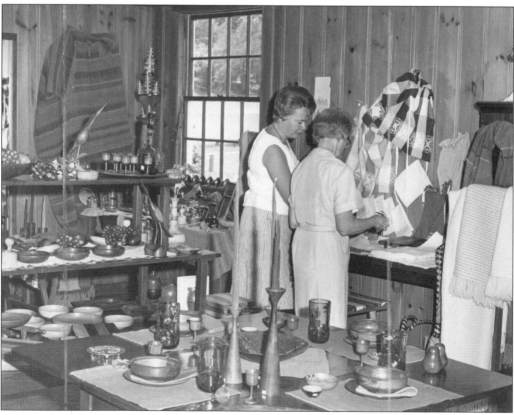

A large variety of handcrafted items were sold at the Pi Beta Phi Arrowcraft Shop. (Courtesy of Arrowmont.)

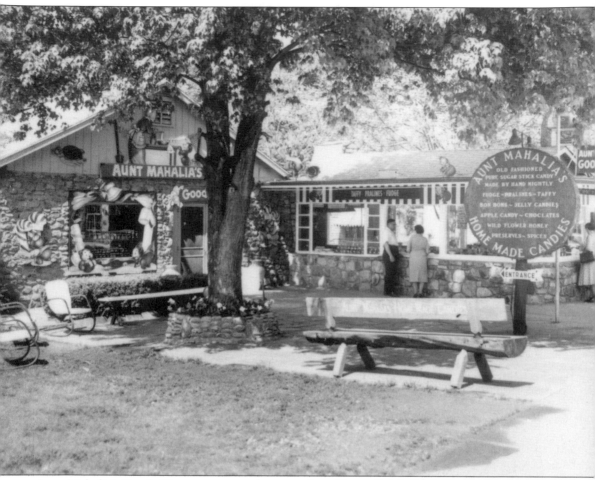

Aunt Mahalia's Candy Shop was across the street from Hattie Ogle's Craft Shop. Charlie Ogle owned the cabin that became the first Aunt Mahalia's, started by Lib and Courtney Jourolman. (Courtesy of Charlynn Maxwell Porter.)

Candy Connor is enjoying the toffee made at her father, George's, store. (Courtesy of Charlotte Connor.)

George Connor, who owned Aunt Mahalia's in the 1940s, is making candy. (Courtesy of Charlotte Connor.)

Crafts seen in town were mostly at demonstrations. Hattie Ogle's Crafts, on the main street through town, and the Smoky Mountain Handweavers were exceptions. (Courtesy of GSMNP.)

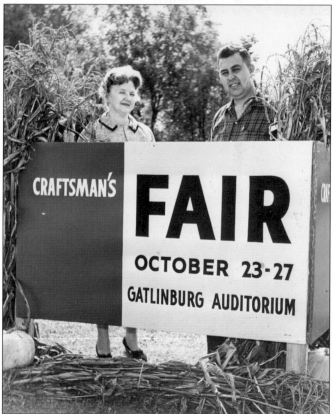

Marion Mueller and Don Ward, who made furniture, stand behind an early craftsman's fair sign. (Courtesy of Arrowmont.)

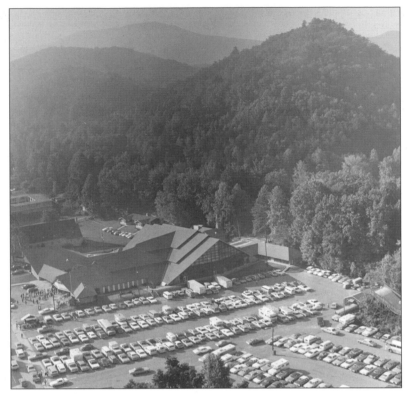

Mills Auditorium was home to the Southern Highlands Craft Fair until the fair was moved to Asheville in the 1960s. Named for Mayor W.L. "Bill" Mills and designed by Hubert Bebb in a "swooping style," it housed Anna Porter Public Library in a front corner until the Cherokee Orchard library building was constructed in 1972. (Courtesy of SHCG.)

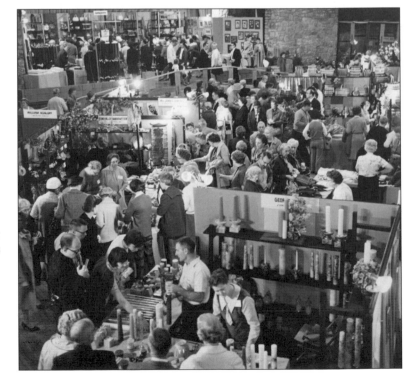

The Southern Highlands Craft Fair in Mills Auditorium brought thousands of visitors to Gatlinburg. After the Southern Highlands Fair moved, the Gatlinburg Craft Fair took its place. (Courtesy of SHCG.)

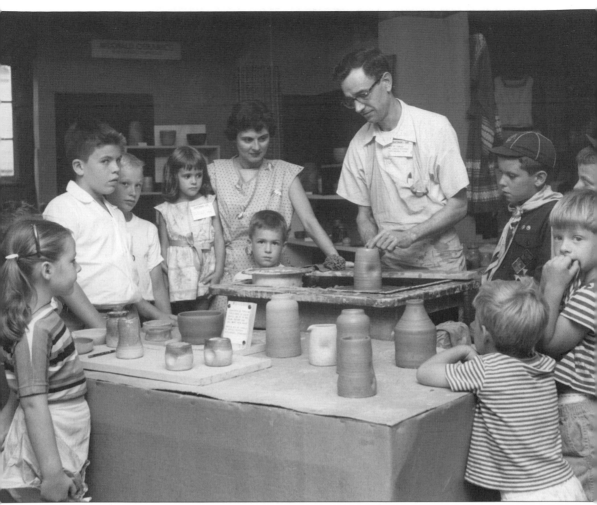

Ken and Barbara McDonald demonstrated pottery making at a Craftsman's Fair. (Courtesy of SHCG.)

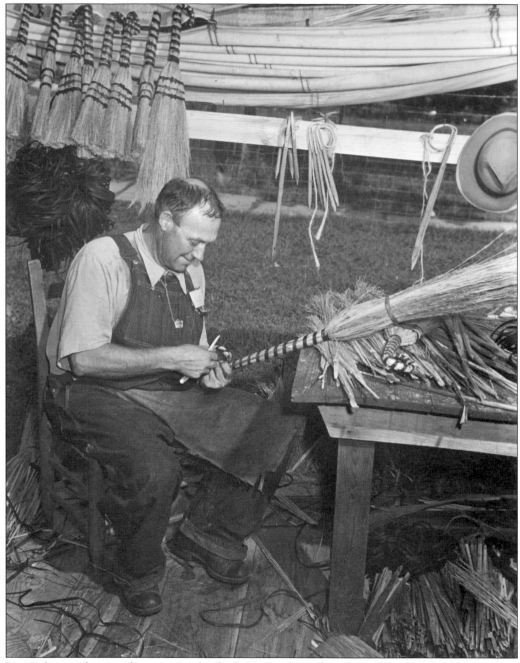

Lee Ogle grew his own broom corn for the broom-making shop, located on the Craft Tour route, that he ran with his brother Wayne. (Courtesy of SHCG.)

Tina McMorran was weaving supervisor at Arrowcraft from 1949 to 1959. She is shown demonstrating at a Craftsmen's Fair in the 1950s. (Courtesy of SHCG.)

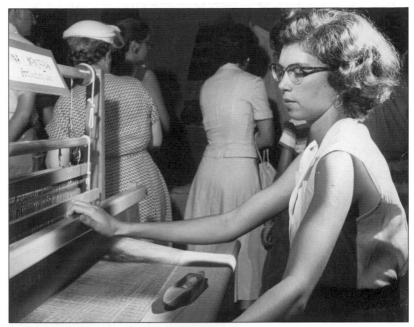

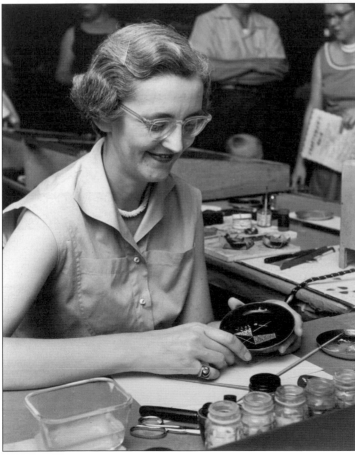

Jane Glass operated The Jane Glass Studio, where she sold jewelry and enamels. (Courtesy of SHCG.)

These two images are flip sides of the first brochure advertising the Glades Craft Tour. As early as the 1920s, the property owners on Glades Road had begun the switch from agriculture to arts and crafts for the tourist trade. In 1937, six craft businesses joined forces to advertise collectively and the Great Smoky Arts and Crafts Community was formed. (Courtesy of Bruk McDonald.)

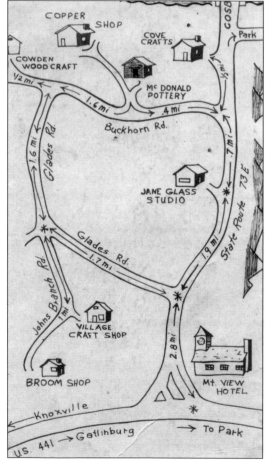

Ken McDonald is shown here working on his pottery. With his wife, Barbara, he moved McDonald Pottery to Glades Road from the Parkway and was instrumental in initiating the Glades Craft Tour. (Courtesy SHCG.)

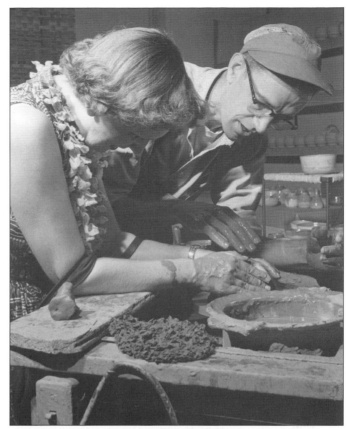

Around 1937, John Cowden decided to stop working for someone else and opened his home on Glades Road to invite people to visit with his wife and children and to see his woodcarvings of animals and fruit. In this later photograph, he is shown working on a carving. Cowden had one of the early shops on the Craft Tour. (Courtesy of SHCG.)

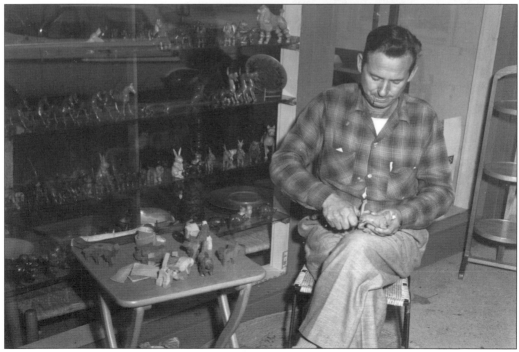

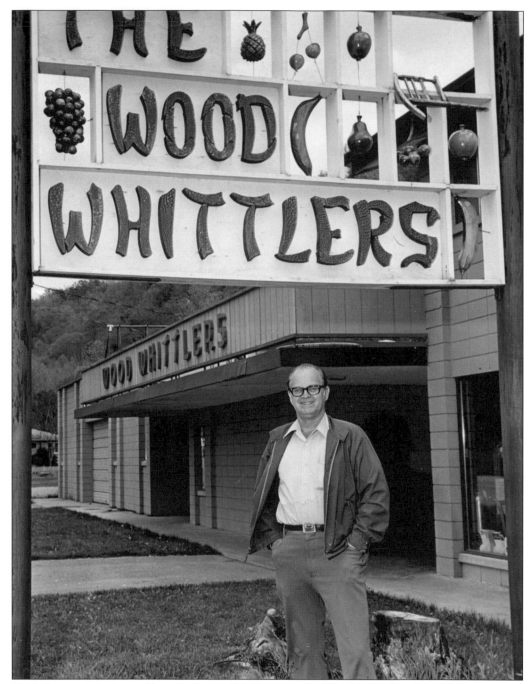

Shirl Compton is pictured here in front of his business, the Wood Whittlers, located at the corner of Glades Road and Highway 321. Shirl and Roy Compton, as well as Isaac Ogle and Carl Huskey, learned their craft from O.J. Mattil, who formed the Gatlinburg Woodscrafters and Carvers when manual training was discontinued at the Pi Beta Phi Settlement School around 1932. (Courtesy of SHCG.)

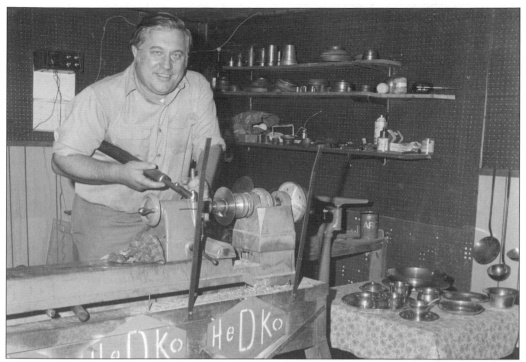

Helmut Koechart was known as "the metal spinner" and demonstrated at a craft fair. (Courtesy of SHCG.)

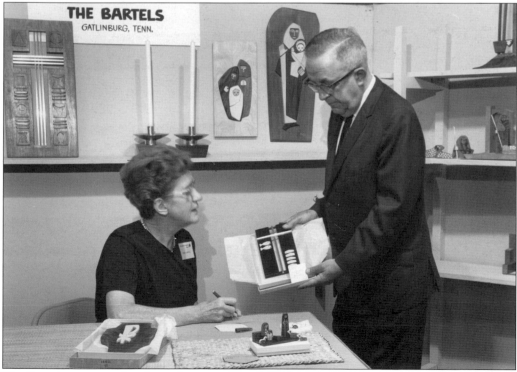

The Bartels were woodcrafters who participated in the craft fairs. (Courtesy of SHCG.)

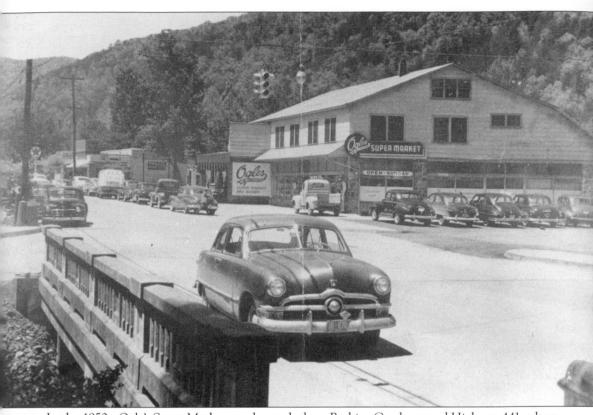

In the 1950s, Ogle's Super Market was located where Baskins Creek crossed Highway 441, where Mountain Mall is now. (Courtesy of GSMNP.)

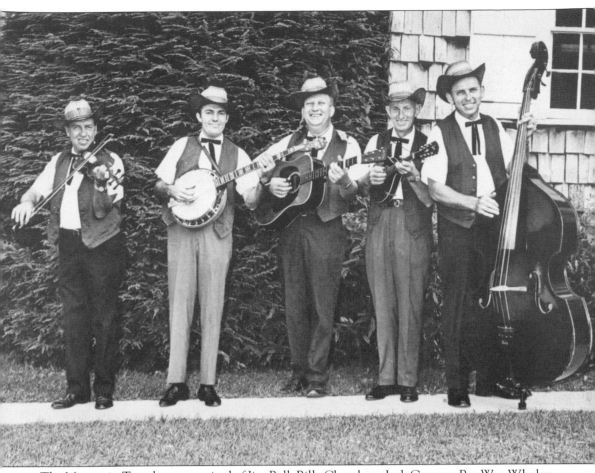

The Mountain Travelers, comprised of Jim Ball, Billy Chambers, Jack Grooms, Pee-Wee Whaley, and Fred McMahan, provided street entertainment in the 1950s. (Courtesy of Charlynn Maxwell Porter.)

After the Seattle World's Fair, someone thought that Gatlinburg needed a space needle. (Courtesy of Wilma Maples.)

Eight

No Longer an Isolated Mountain Community

In the 1960s, Gatlinburg developed even more innovative ways to accommodate the tourists that were flocking to the town, and according to Ed Trout, "the character of modern Gatlinburg began to take shape." New attractions were added that would appeal to a wider range of interests. In 1962, the City of Gatlinburg turned Mount Harrison into a ski mountain and opened the $1 million Gatlinburg Ski Resort, complete with lifts and a lodge for après-ski entertainment. Ten years later, Claude Anders would buy the resort, install the aerial tramway, and call it Ober Gatlinburg. Ronald Ligon built Christus Gardens, a New Testament wax museum, to serve a specific audience. In this decade of lower gas prices, upwardly mobile middle class folks were traveling. Gatlinburg adjusted to this "new public" that demanded more than large hotel dining rooms and mountain views.

On the old Pi Beta Phi Settlement School grounds, the Pi Beta Phi Fraternity added a new weaving building, a wing for classes in ceramics, well-equipped studios, and a library. By the end of this decade, the Sevier County Board of Education had taken over management of the local schools. With education and health care provided by other entities, the Pi Phis turned their 70-acre campus in the middle of downtown Gatlinburg into the Arrowmont School of Arts and Crafts, and its operation became their major philanthropy.

Meanwhile, shops, restaurants, and motels were prospering and remodeling to update their appearance. The number of beds available for tourists increased by 50 percent between 1967 and 1971. New artists joined Gatlinburg's prosperous artist community on Glades Road, and the number of artists who lived and worked in that one area became the largest group of independent craftspeople in the United States.

The new style of tourism brought an influx of traffic and abundance of shops selling T-shirts and other items costing far less than the original art created in local studios. The tourism economy also supports 11,000 people who choose to work and live in a community with a strong educational system, excellent city services, a public library, a unique history, and a culture that includes working artists and outdoor enthusiasts.

Christus Biblical Gardens, a New Testament wax museum, was built by Ronald Ligon in 1960. That property and an orchard previously belonged to Matt Whittle, who lived in the white house still on Christus Gardens' property. (Courtesy of TSLA.)

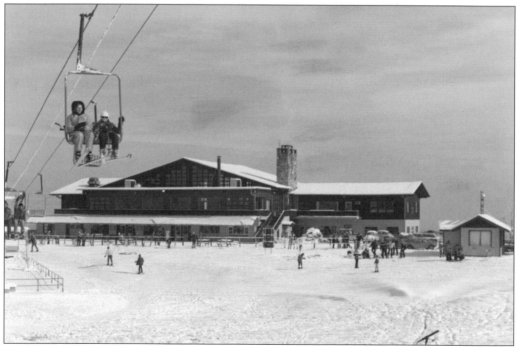

The Gatlinburg Ski Resort, owned by the City of Gatlinburg, opened for business in 1962, on the top of Mount Harrison. Dick Whaley was instrumental in its development. (Courtesy of Mary Louise Hunt.)

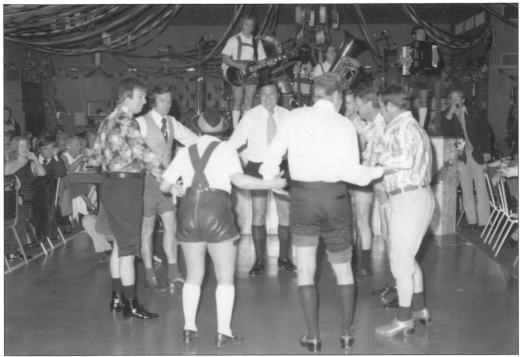

Visitors to the ski resort could be entertained by polka dancers at the Old Heidleberg Castle restaurant. (Courtesy Gheesling/Trotter.)

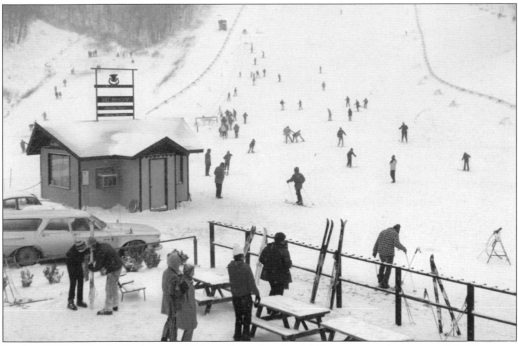

In the 1970s, Claude Anders would introduce the Aerial Tramway to the successful ski resort. Today, it is known as Ober Gatlinburg and has extensive snow-blowing equipment and 900,000 visitors annually. (Courtesy Mary Louise Hunt.)

After artist Jim Grey visited in the 1960s from the Gulf Coast, he soon moved to Gatlinburg and opened his first studio in an old pottery shop on Buckhorn Road. (Courtesy of Greenbrier, Inc.)

Otto J. Mattil, seen here in a photograph from 1960, came to the Pi Beta Phi Settlement School in 1922. He taught furniture and cabinetmaking, demonstrated orchard care and crop rotation, and established the school's Woodcrafters and Carvers Shop. Because of Mattil, many young men were able to begin successful careers building custom furniture. He later opened a shop at a site that today is The Village. (Courtesy of Mary Louise Hunt.)

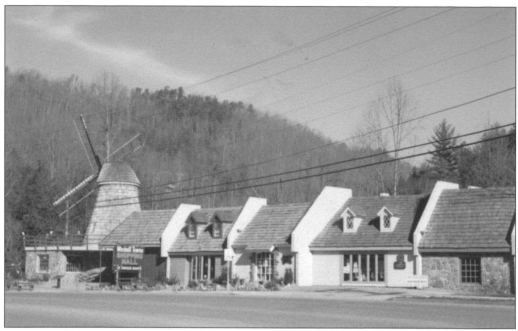

Wallace Zoder built Windmill Towne Mall in the 1960s, just uphill from the intersection of Highways 321 and 441. (Courtesy Mary Louise Hunt.)

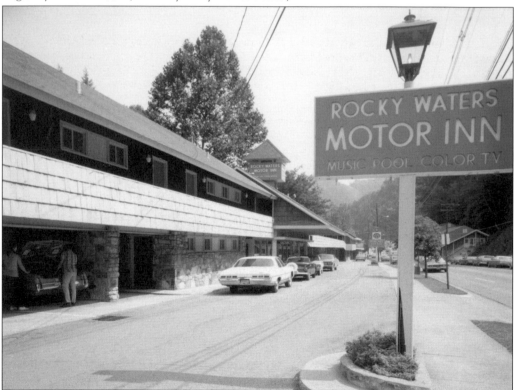

The original Rocky Waters was built by Andy Huff and housed a tea room in its lower level. (Courtesy of Bud Lawson.)

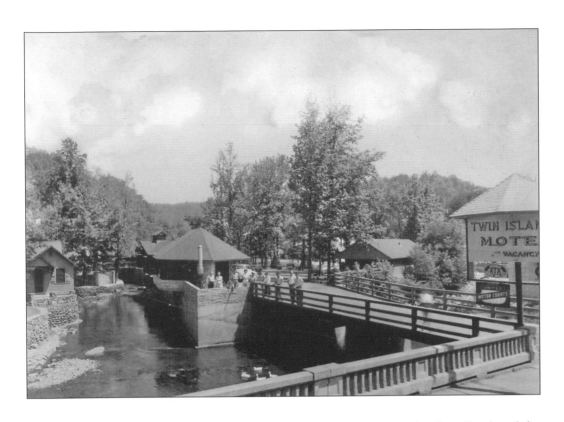

The Twin Islands Motel was built on "islands" formed at the confluence of Baskins Creek and the Little Pigeon River, where Pleasure Island had been. A bridge crossing was necessary for visitors to get to the motel. Below is a front view of Twin Islands Motel once the island crossing has been made. (Above, courtesy of Bud Ogle; below, courtesy of Blouin/APPL.)

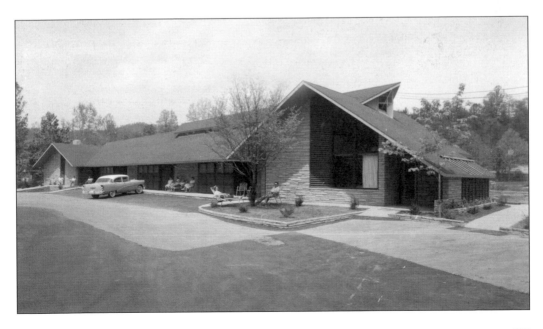

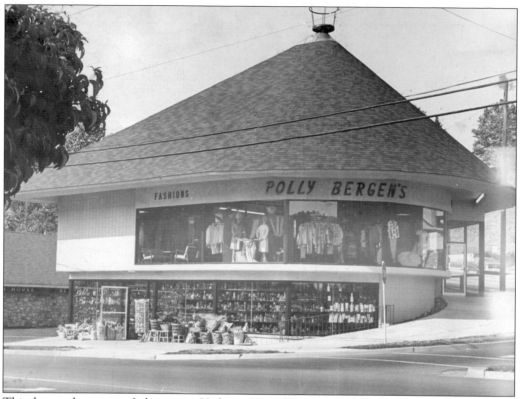

This shop at the corner of what is now Highway 321 and Highway 441 was built by Bud Lawson about 1964 and was owned by actress Polly Bergen, a native of the area. (Courtesy of Bud Lawson.)

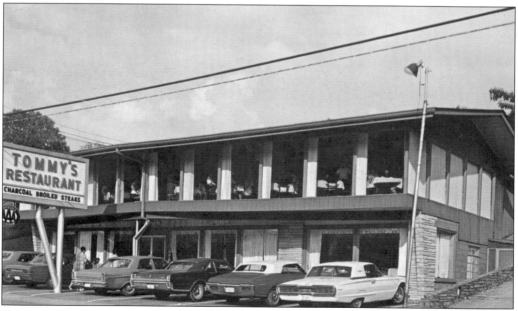

Tommy's Restaurant served good, old-fashioned home cooking for breakfast and lunch. (Courtesy of Blouin/APPL.)

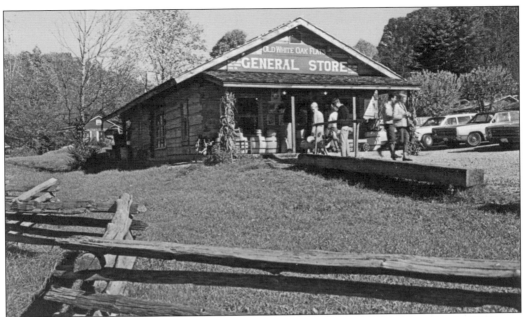

The General Store was on Highway 321 near the location of the Craft Center and today's Winery Square and sold a variety of Smoky Mountain products, like jellies and brooms. (Courtesy of Blouin/APPL.)

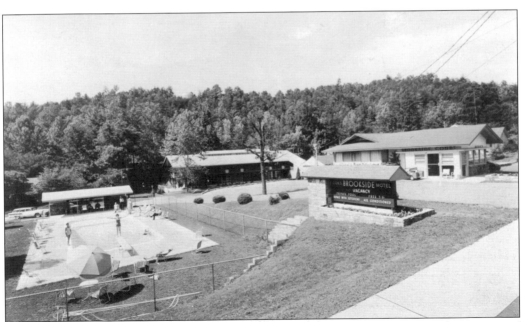

The first Brookside Motel on Highway 321 was owned by Hal Reagan. (Courtesy of Blouin/APPL.)

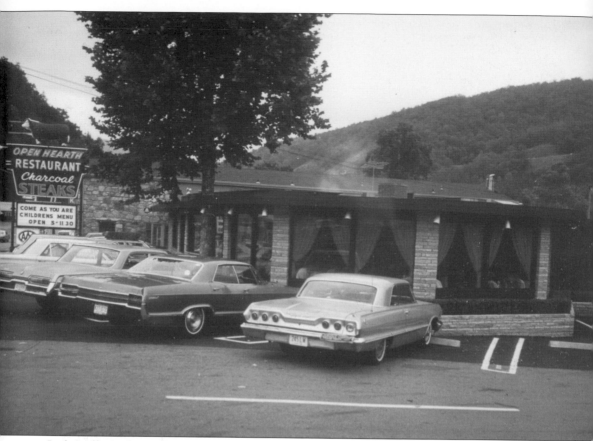

Jack Miller's Open Hearth Restaurant was one of Gatlinburg's most popular. (Courtesy of Weals/APPL.)

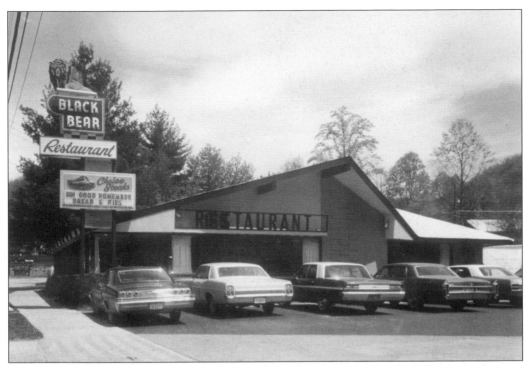

The Black Bear Restaurant was out Roaring Fork Road opposite the Brookside Resort and is now a pancake restaurant. (Courtesy of Weals/APPL.)

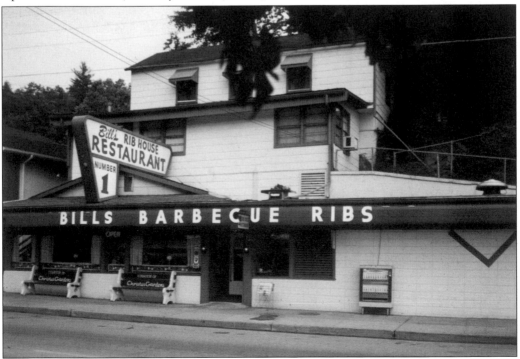

Bill's Rib House Restaurant was located where the Trout House Restaurant sits, next to today's Zoder's Best Western Inn. (Courtesy of Weals/APPL.)

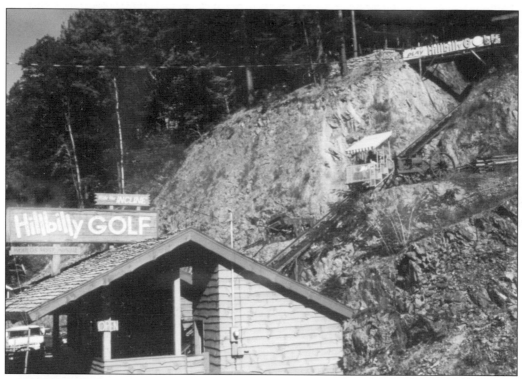

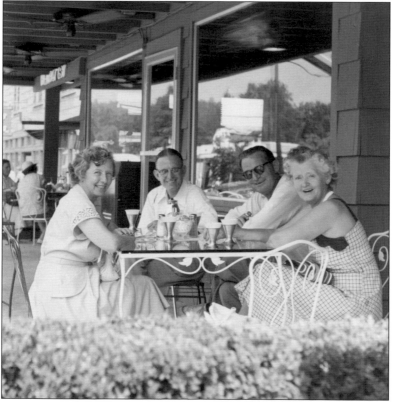

Carpet golf is usually played on flat surfaces, but in Gatlinburg it is played up and down mountainsides. Local entrepreneurs were happy to adapt "hillbilly" styles, if that image would draw more tourists. (Courtesy of Weals/APPL)

People enjoyed the patio of Howard's Restaurant in the 1960s, just as they do today. (Courtesy of Charlotte Connor.)

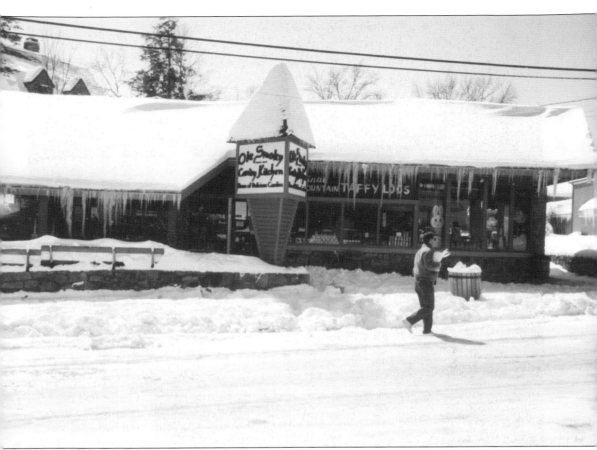

The Old Smoky Candy Kitchen property was purchased by David and Peggy Dych from R.L. Maples in 1965 and, with the Pancake Pantry property, purchased by Jim and June Gerding, became the basis for development of The Village near the corner of Highway 441 and Cherokee Orchard Road. (Courtesy of Charlotte Connor.)

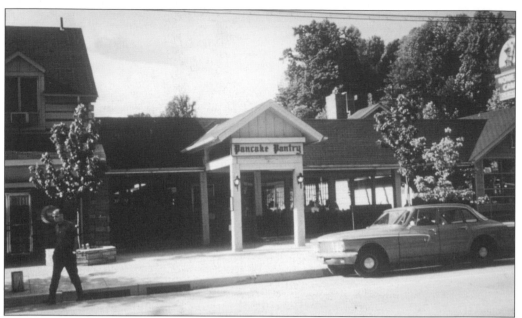

The Pancake Pantry was opened by Jim and June Gerding on the site of O.J. Mattil's woodworking shop. (Courtesy of Jim and June Gerding.)

The Village, with its European feel, was featured in *Southern Living* magazine when it first opened in 1969. Unique in 1960s Gatlinburg, the shopping concept of Jim and June Gerding and David and Peggy Dych was drawn from authentic restorations nationwide and used an Old World theme. (Courtesy Mary Louise Hunt.)

To be more visible, the Pancake Pantry added a new entryway. (Courtesy of Jim Gerding.)

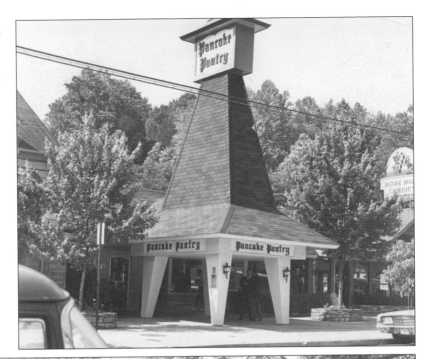

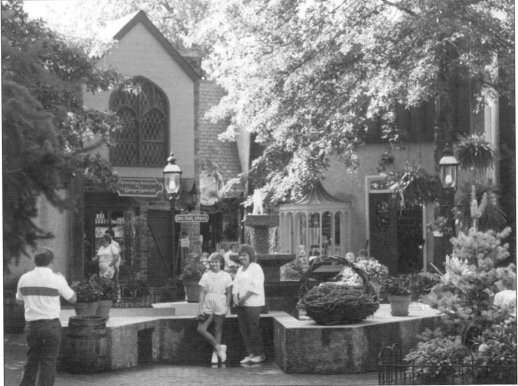

Tourists in The Village now reflect a different lifestyle from the Pi Beta Phi Fraternity ladies visiting Anna Reagan's house to look at weaving some 60 years ago, pictured in chapter two. (Courtesy of Jim Gerding.)

In 1969, the Pi Beta Phi Fraternity for Women decided that their Pi Beta Phi Settlement School and its Summer Craft Workshop should become the Arrowmont School for Arts and Crafts. Architect Hubert Bebb designed a new central building complex nestled against a hillside on the Pi Phi property in the center of Gatlinburg. (Courtesy of Arrowmont.)

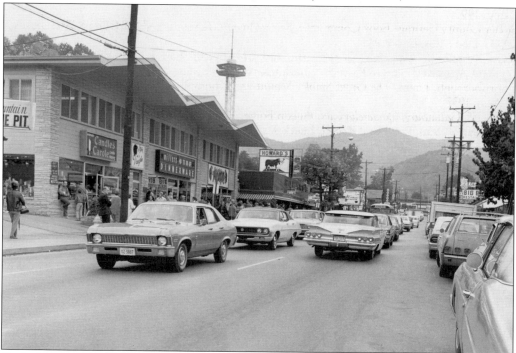

Gatlinburg traffic on Highway 441, now known as the Parkway, has picked up significantly since the bare streets seen in the 1913 photograph in chapter one. (Courtesy of Mary Louise Hunt.)

BIBLIOGRAPHY

Aiken, Jane and Gene. *Mountain Ways*, Gatlinburg, TN: The Buckhorn Press, 1983.

———. *Mountain Ways Two*, Gatlinburg, TN: The Buckhorn Press, 1986.

Alvic, Philis. *Weavers of the Southern Highlands*. Lexington, KY: The University Press of Kentucky, 2003.

Chalmers, Marjorie. *Better I Stay*. Gatlinburg, TN: Crescent Color Printing Company, 1975.

Eaton, Allen H. *Handicrafts of the Southern Highlands*. New York: Dover Publications, 1973.

First National Bank. *Making a Difference for Forty Years, 1951–1991*. Gatlinburg, TN: Escape Publications, Inc., 1991.

Greve, Jeanette S. *The Story of Gatlinburg*. Strasburg, VA: Shenandoah Publishing House, Inc., 1931.

Harshaw, Lou. *Gatlinburg Places of Discovery*. Sykesville, MD: Greenberg Publishing Company. Inc. 1990.

Sevier County Heritage Book Committee. *Sevier County, Tennessee and Its Heritage*. Waynesville, NC: Don Mills, Inc. 1994.

Shaw, Russell. *The Gatlinburg Story*. Gatlinburg, TN: Russell Shaw, Publishing, 1957.

Southern Arts and Crafts, 1890–1940. Charlotte, NC: Mint Museum of Art, 1996.

Thornborough, Laura. *The Great Smoky Mountains*. Knoxville, TN: University of Tennessee Press, 1937.

Trout, Ed. *Gatlinburg, Cinderella City*. Pigeon Forge, TN: Griffin Graphics, 1984.

West, Carroll Van, Ph.D. and Kristin Luetkemeier. *Gatlinburg History and Survey*. Unpublished manuscript, Murfreesboro, TN: Middle Tennessee State University Center for Historic Preservation, 2007.

Discover Thousands of Local History Books Featuring Millions of Vintage Images

Arcadia Publishing, the leading local history publisher in the United States, is committed to making history accessible and meaningful through publishing books that celebrate and preserve the heritage of America's people and places.

Find more books like this at
www.arcadiapublishing.com

Search for your hometown history, your old stomping grounds, and even your favorite sports team.

Consistent with our mission to preserve history on a local level, this book was printed in South Carolina on American-made paper and manufactured entirely in the United States. Products carrying the accredited Forest Stewardship Council (FSC) label are printed on 100 percent FSC-certified paper.

MADE IN THE

USA